Mesdemoiselles

CATS

Colouring for mindfulness

hamlyn

To our big cats!

A big thank you to Patricia, Pascale and Emmanuel

An Hachette UK Company
www.hachette.co.uk

First published in France in 2015 by Marabout

This edition published in Great Britain in 2015 by
Hamlyn, a division of Octopus Publishing Group Ltd
Carmelite House
50 Victoria Embankment
London
EC4Y 0DZ
www.octopusbooks.co.uk

ISBN 978-0-600-63302-0

A CIP catalogue record for this book is available from the British Library.

Printed and bound in China

15 14 13

Layout: Else
Translation: JMS Books LLP (www.jmswords.com)
Senior Production Manager: Katherine Hockley

This book belongs to:

..

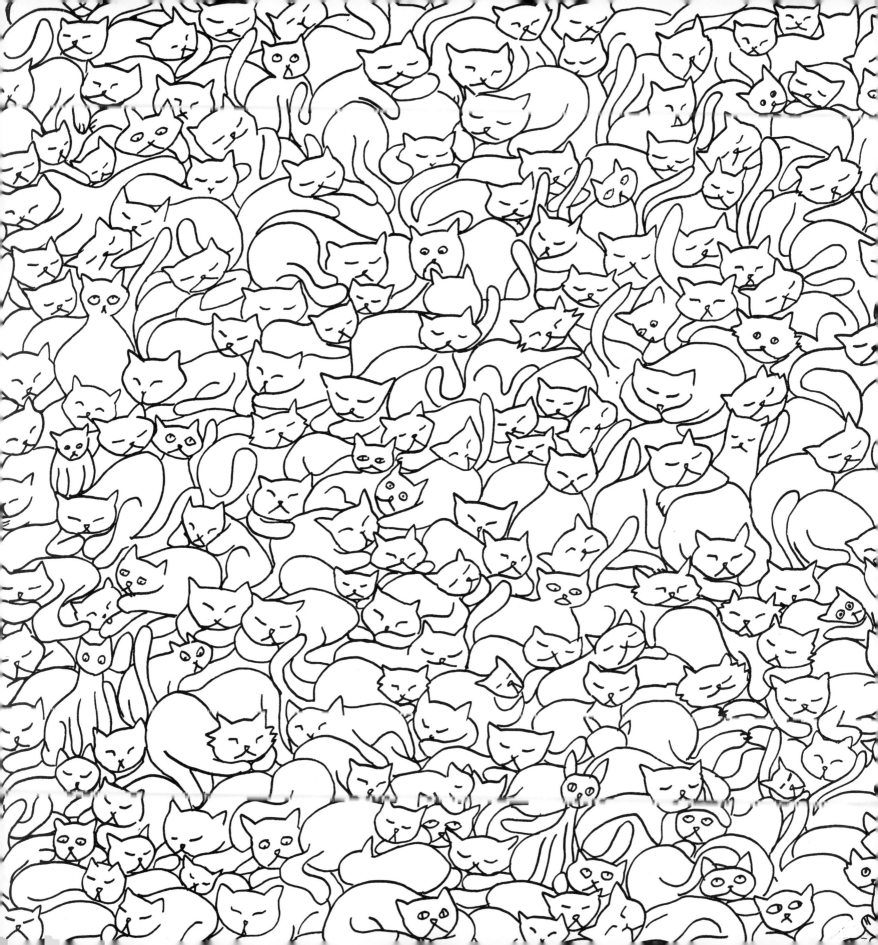

Which cat are you?

Sophisti-cat or alley cat?
Sad cat or happy cat?
Mangy moggy or posh Persian?
Sleepy cat, acrobat cat or inscrutable cat?
Seducer, bon viveur, explorer?

Cats everywhere
Up to all sorts of things...
Follow their paw prints through these pages
These fabulous felines
Outlined in black and white by
Mesdemoiselles.

Pick up your colouring pencils
Grab your paints
This fabulous family of felines
Will awaken the pussycat in you!

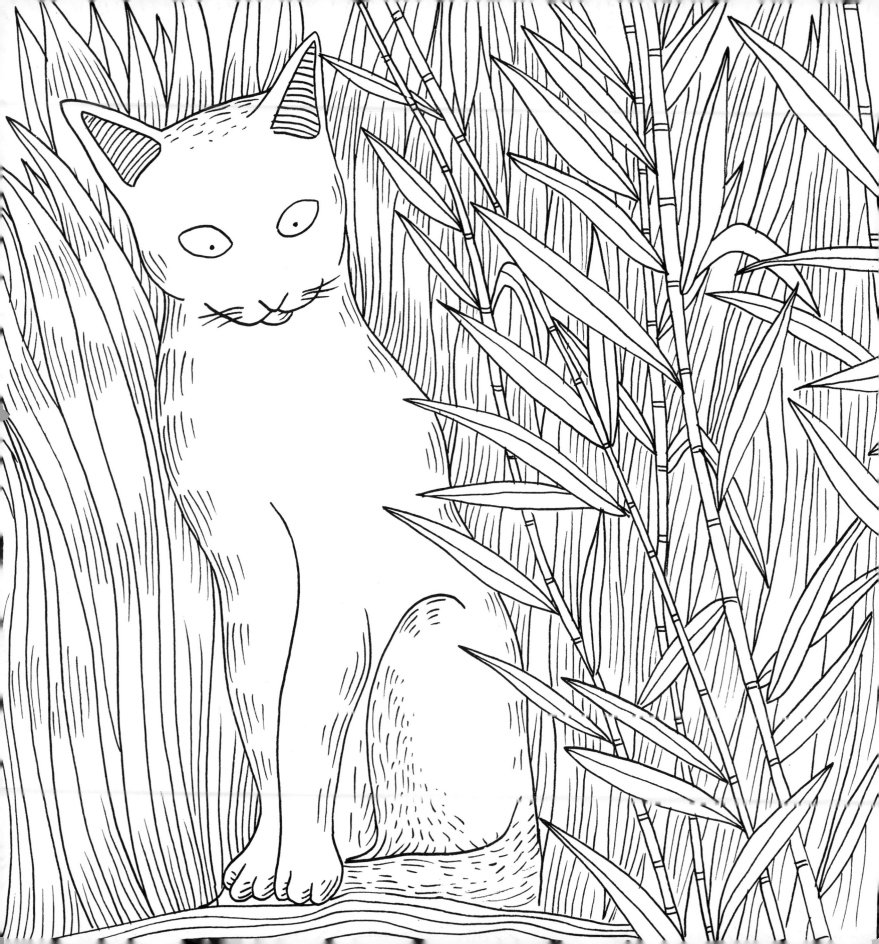

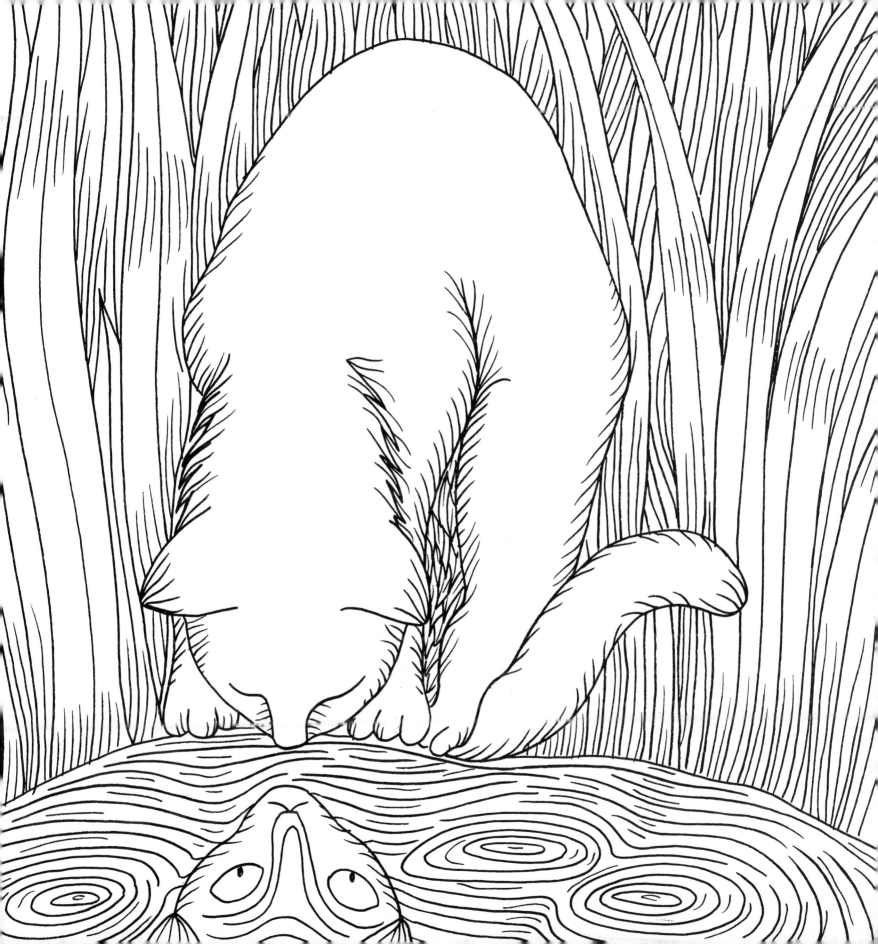

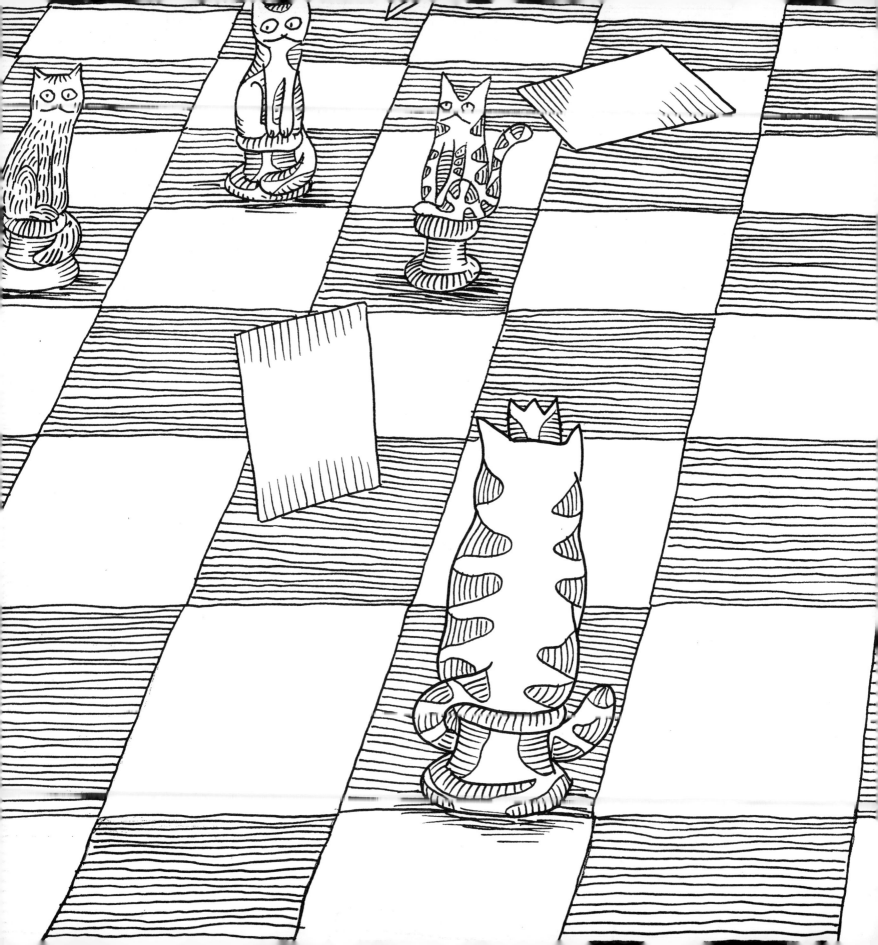

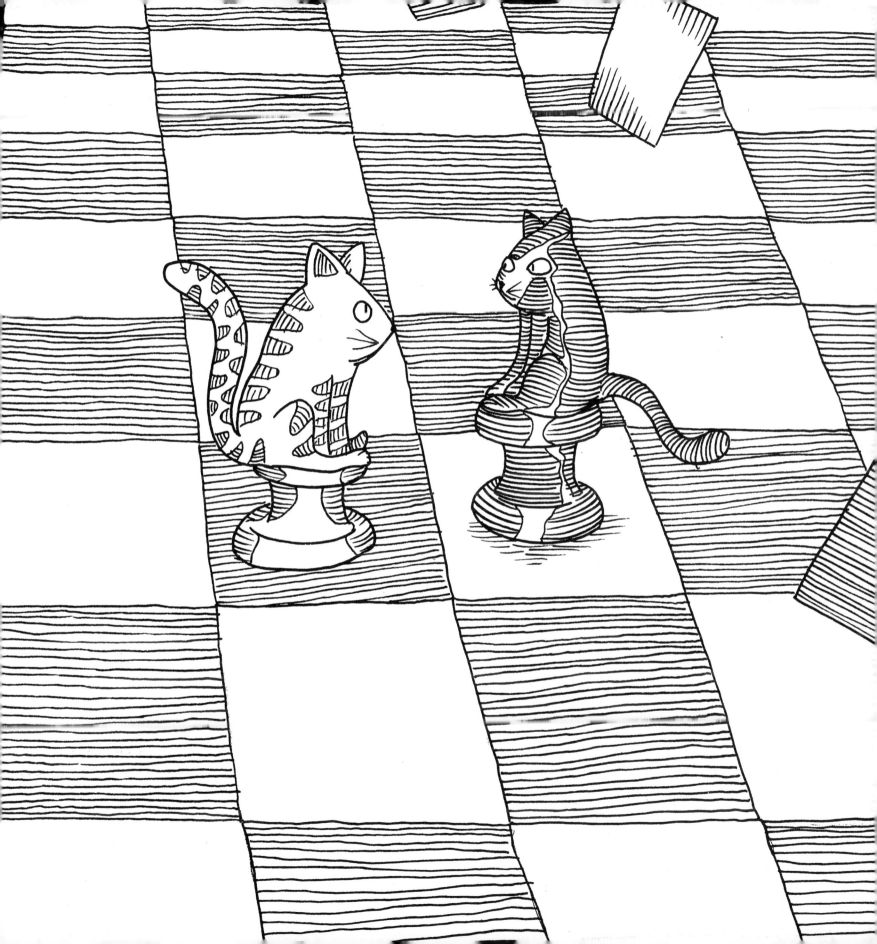

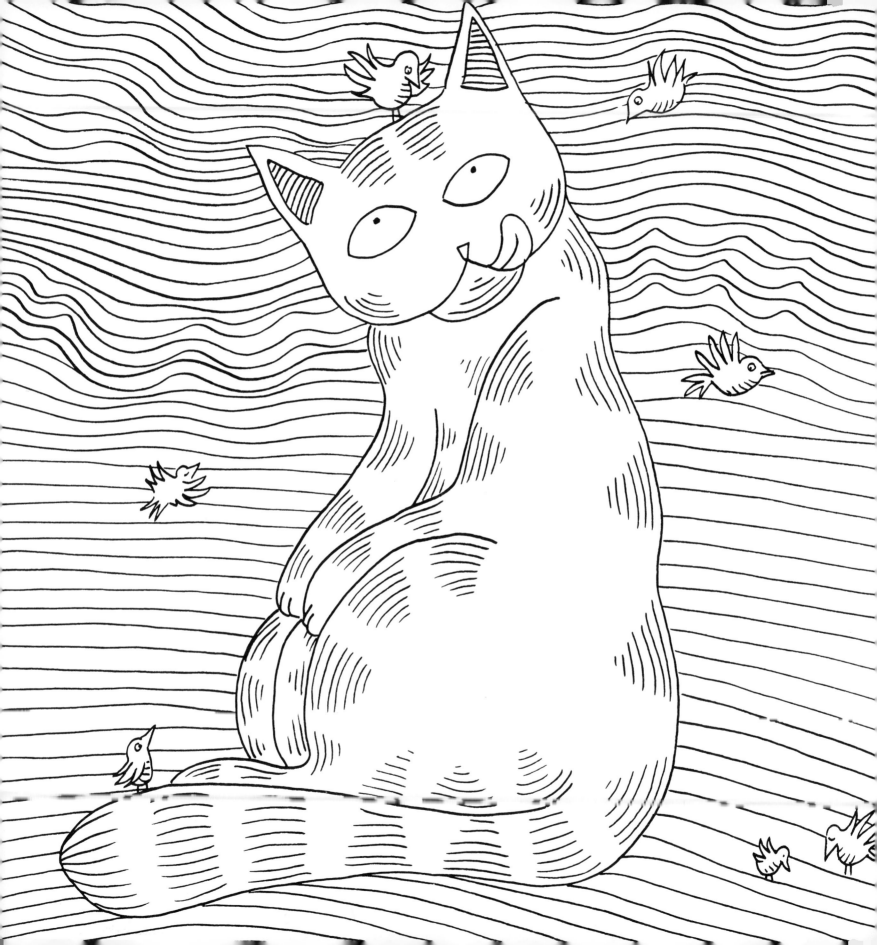

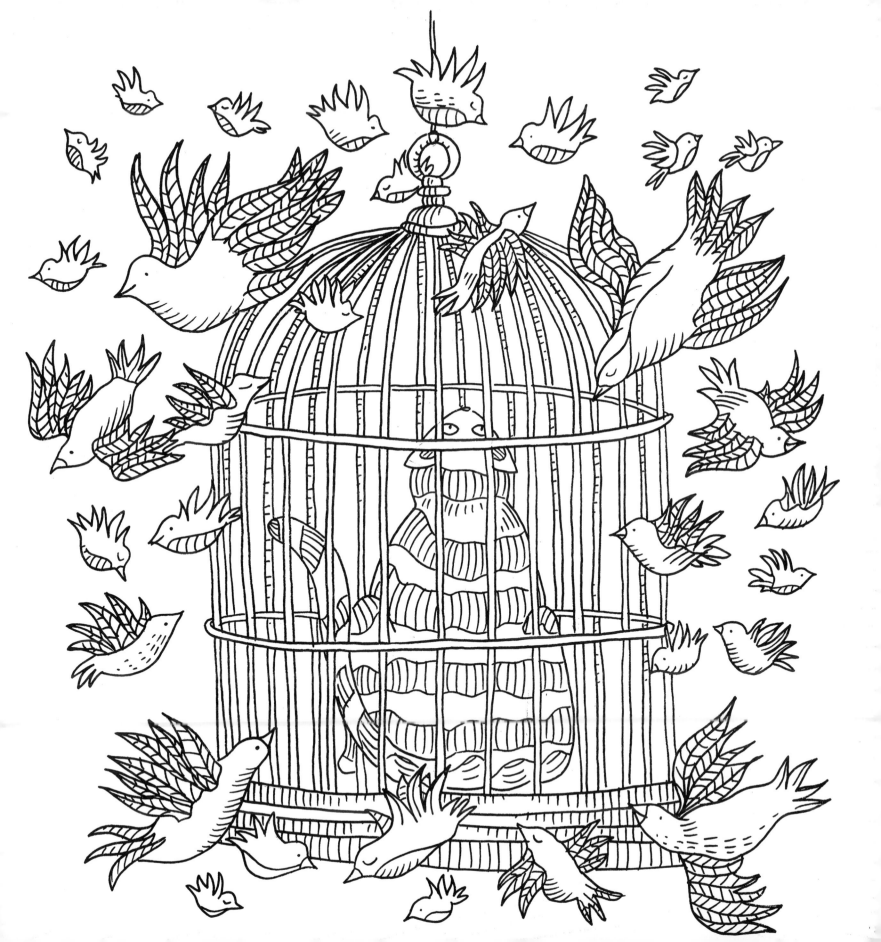

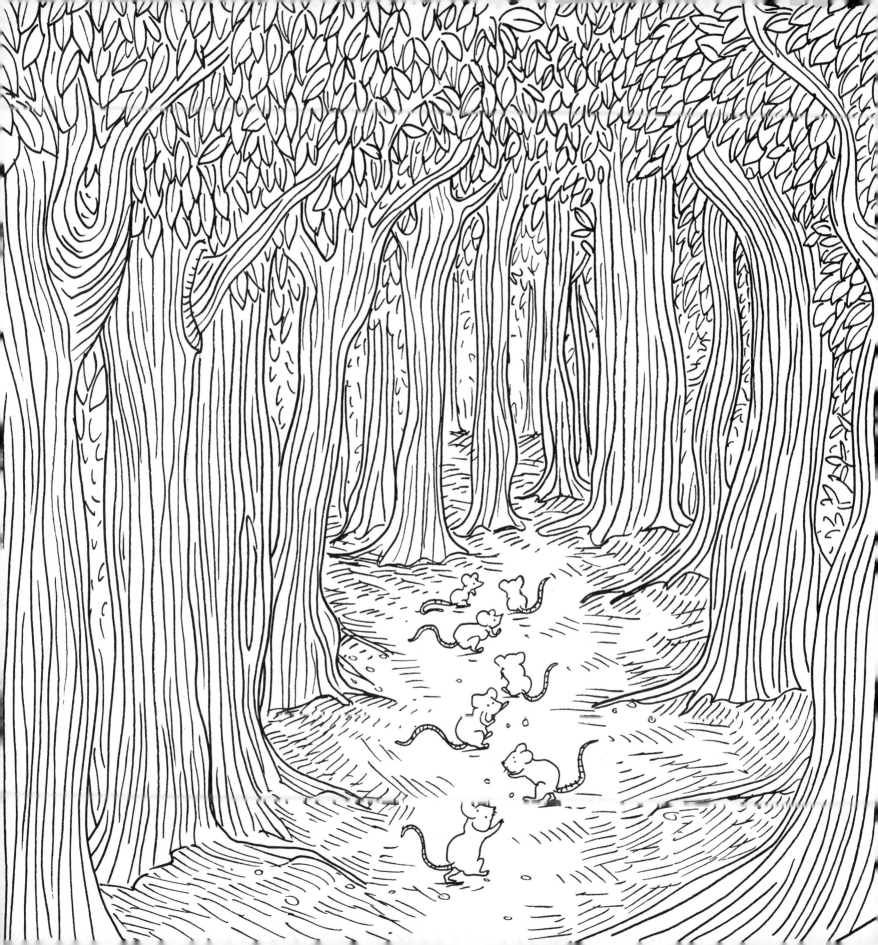

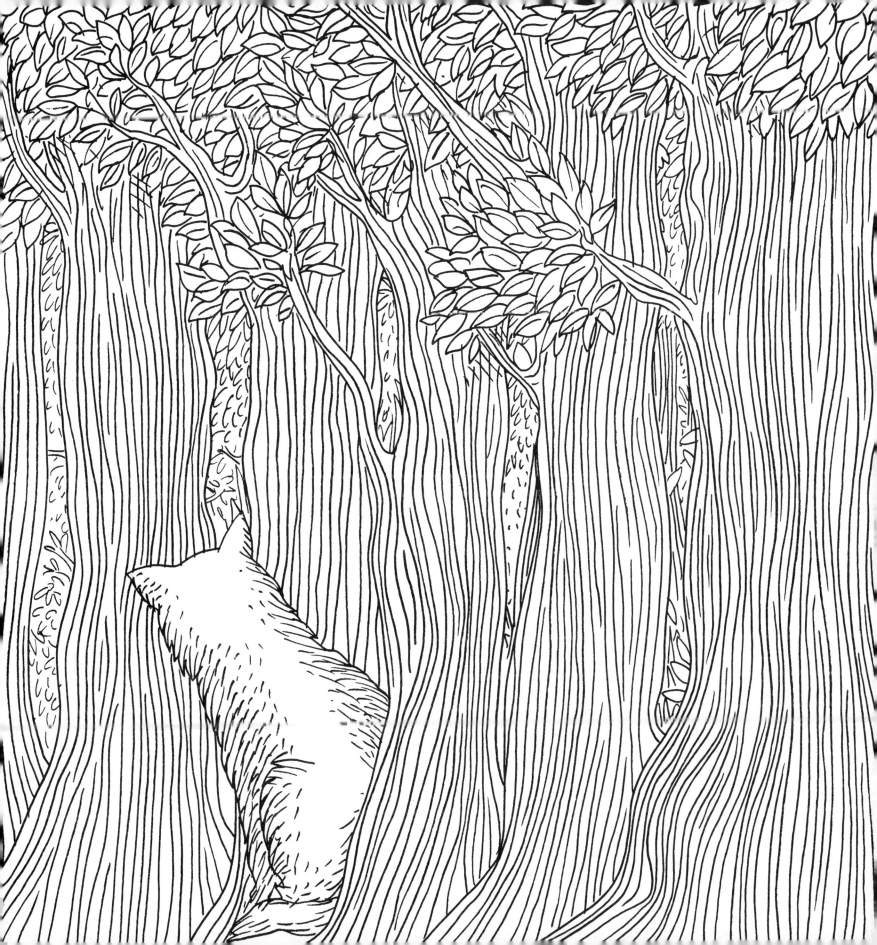

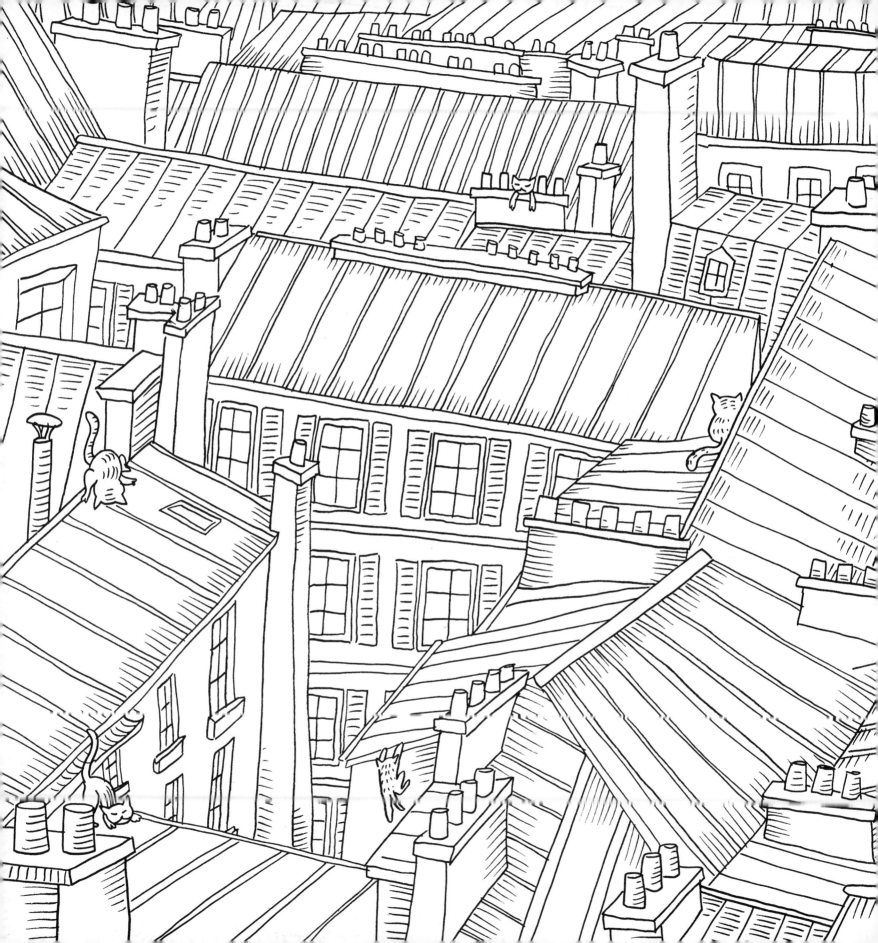

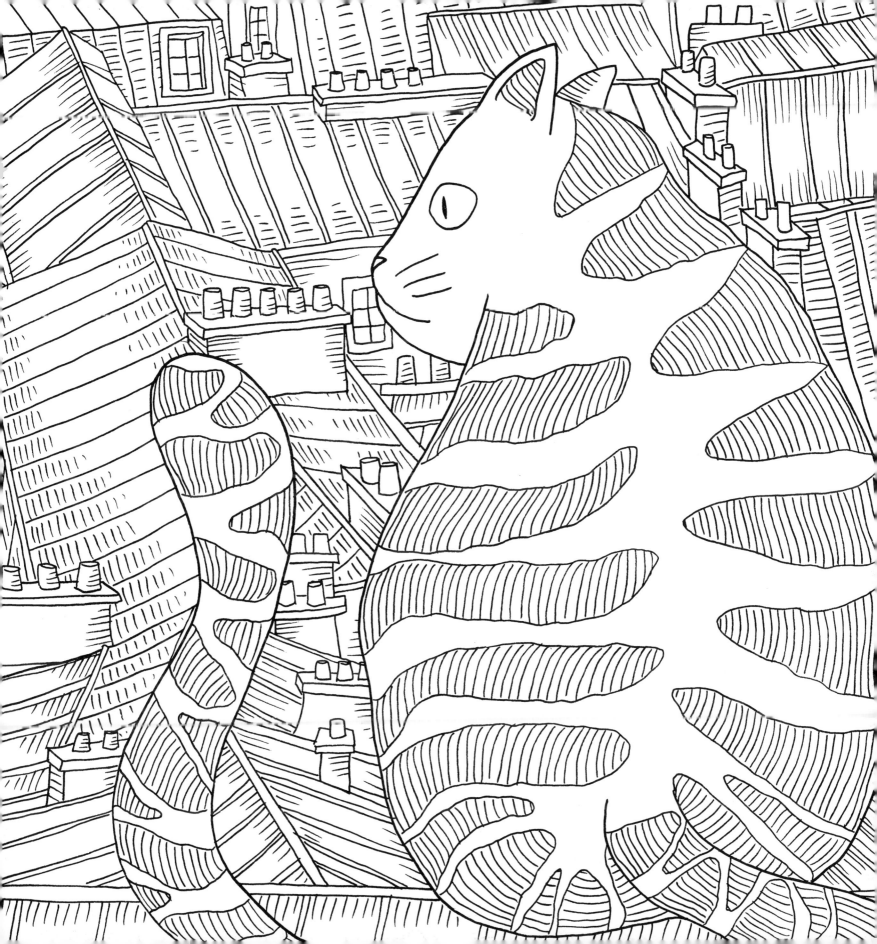

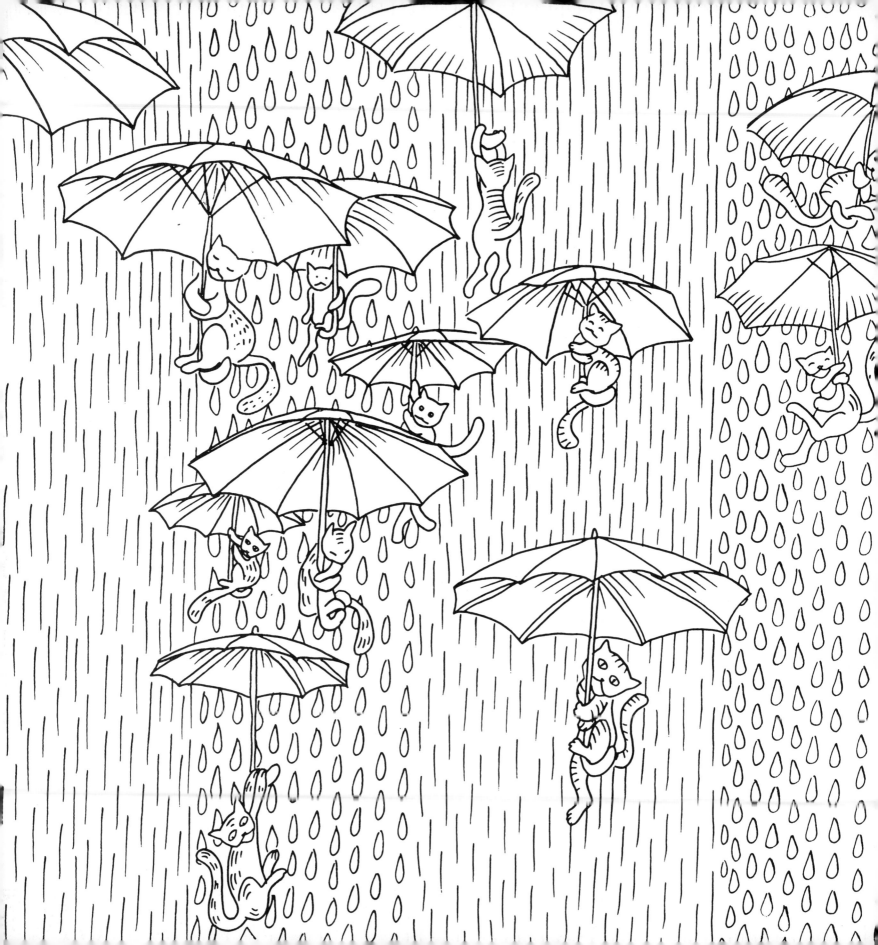

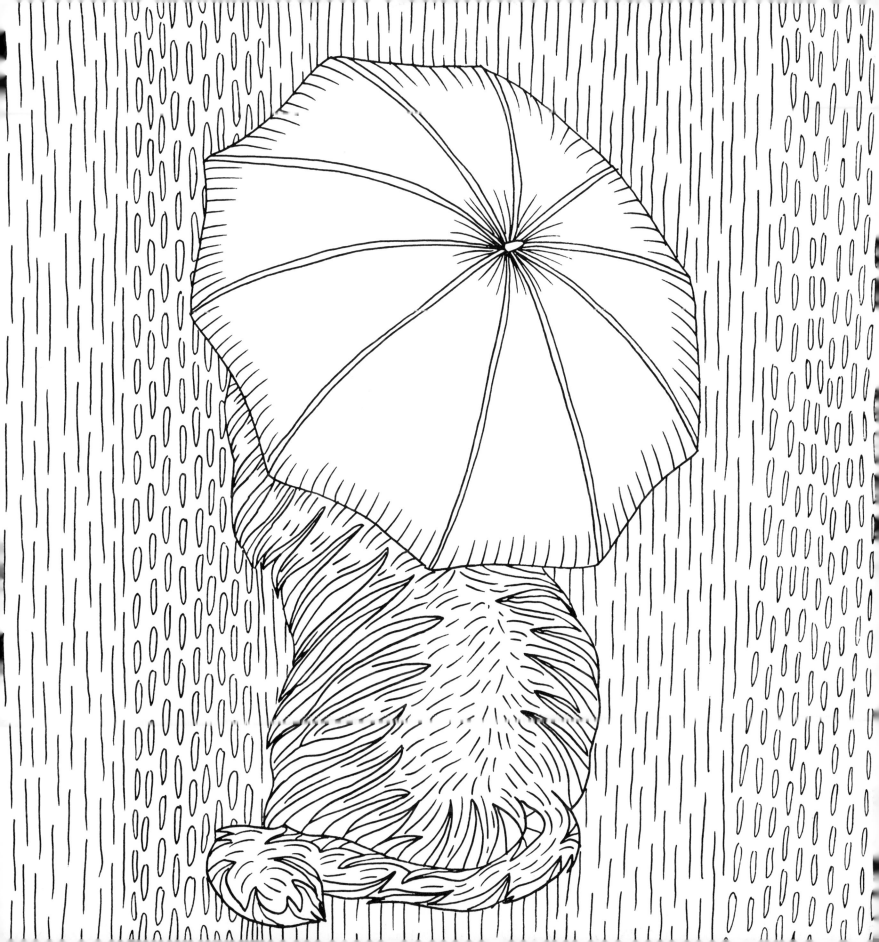

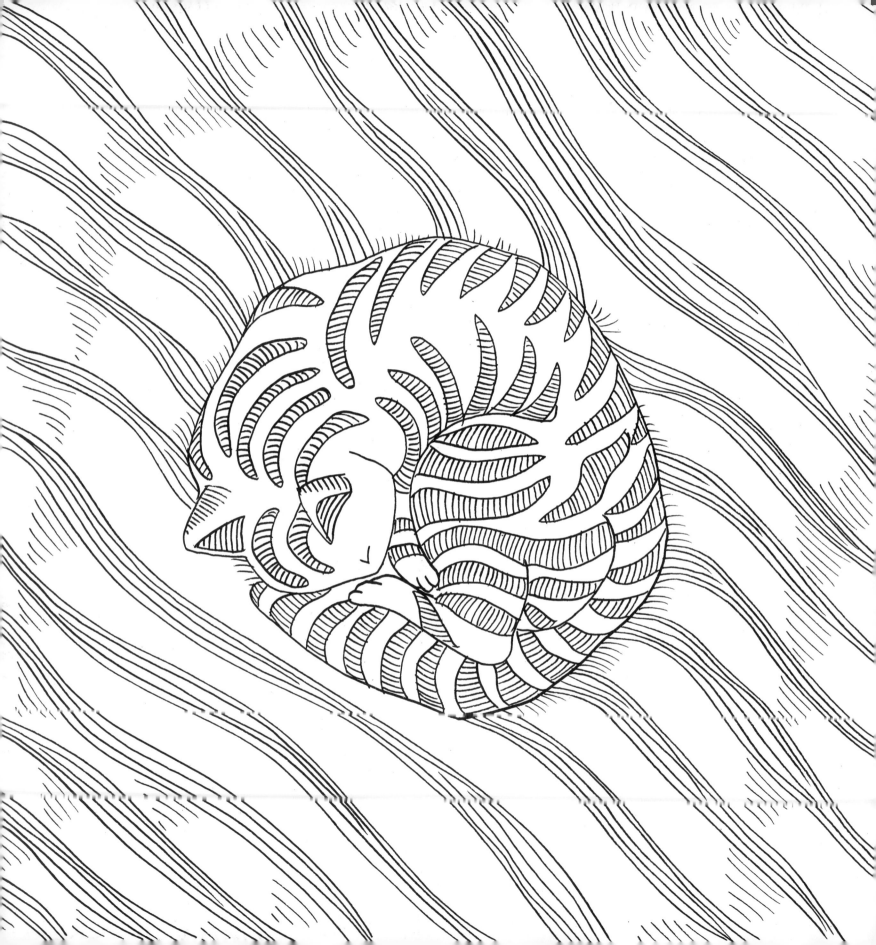

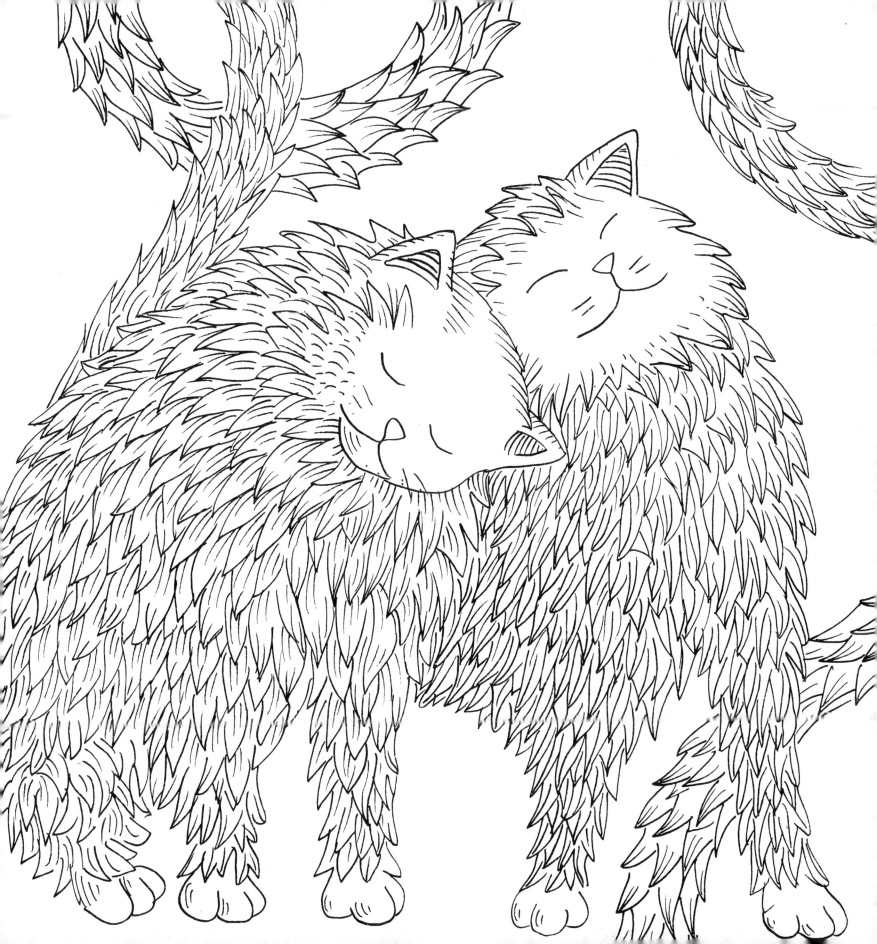

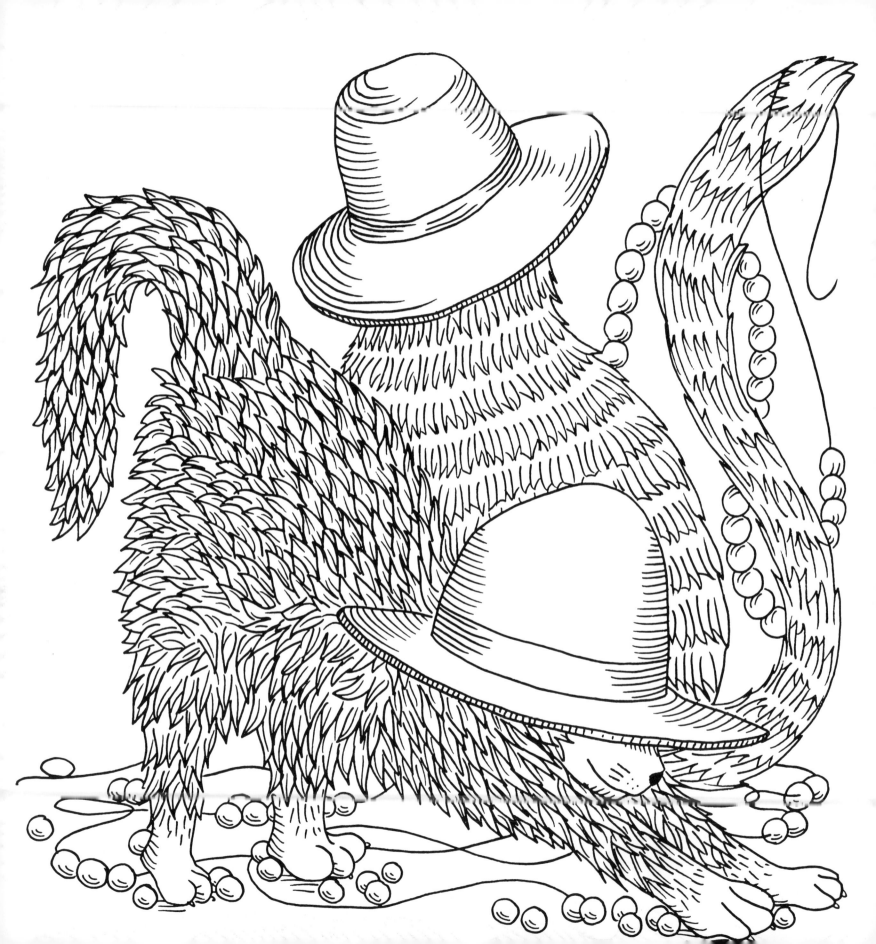

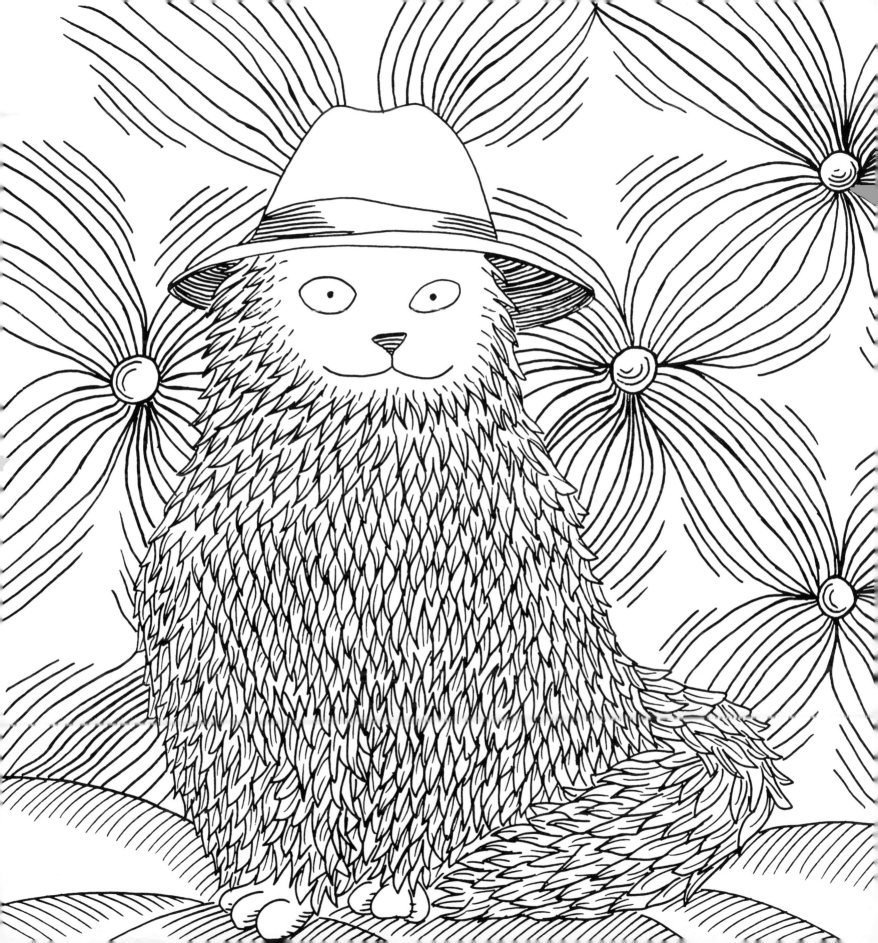

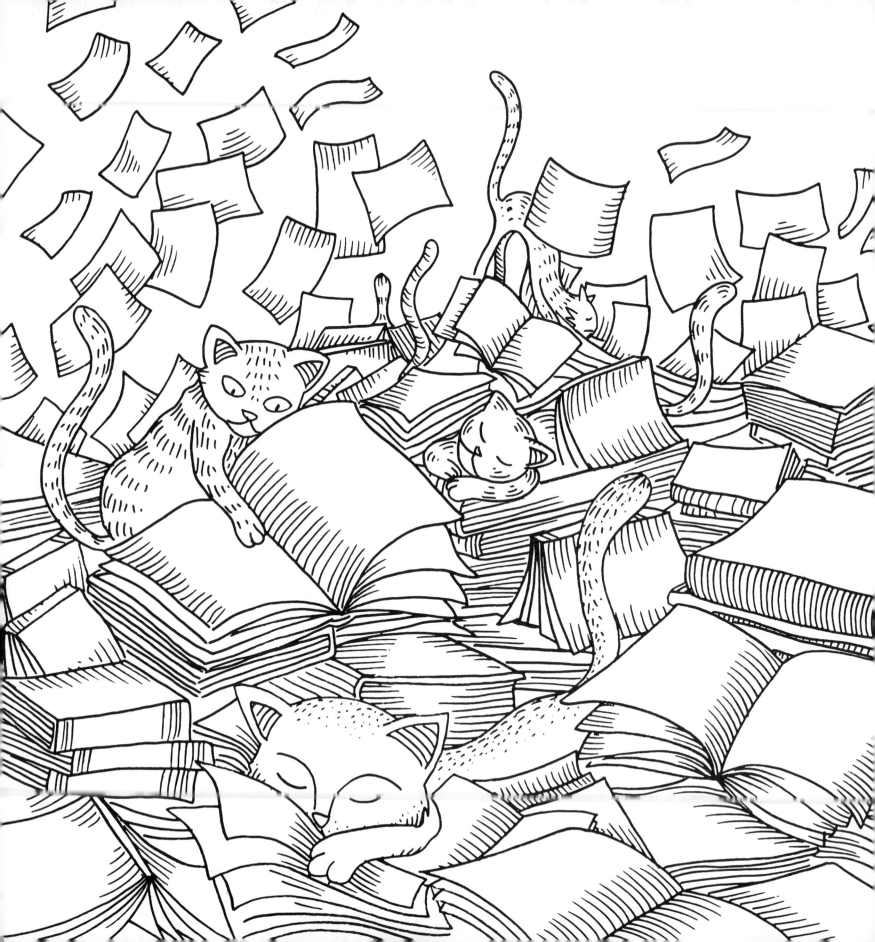

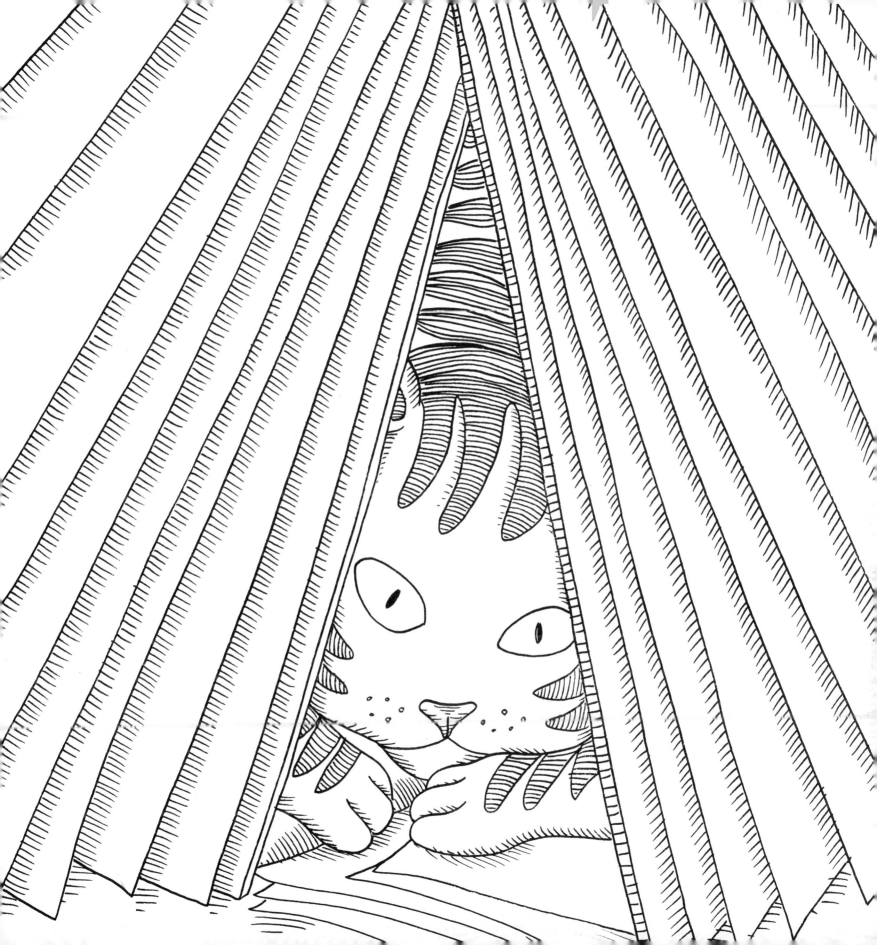

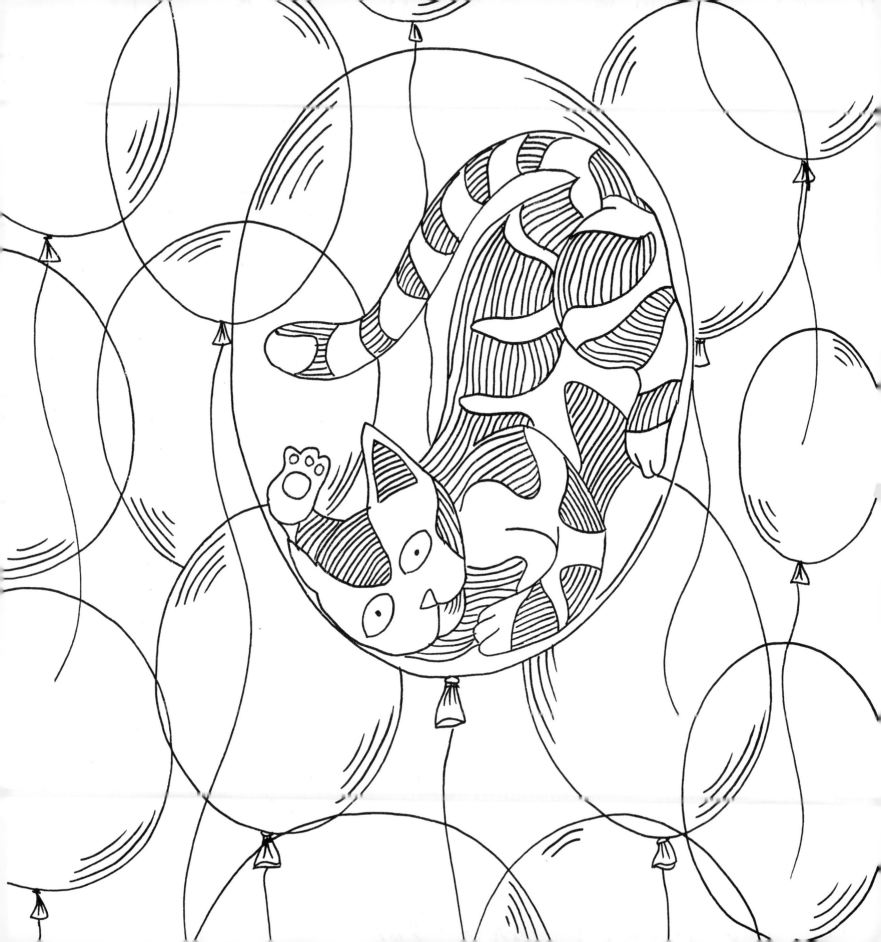

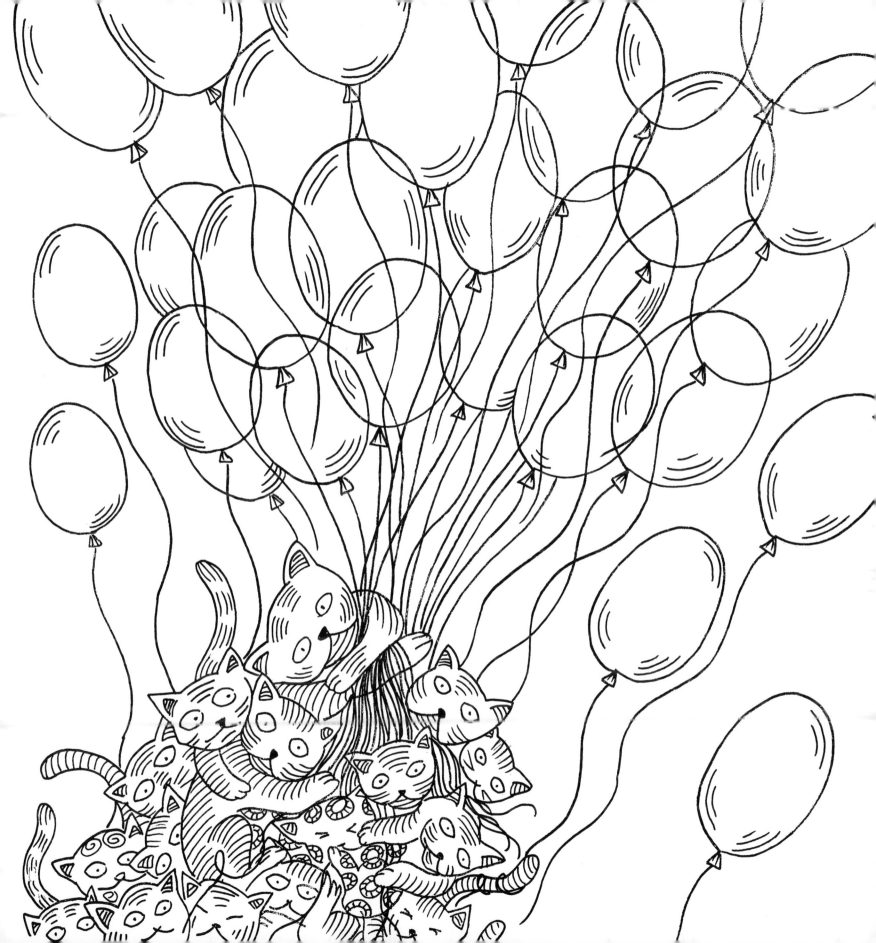

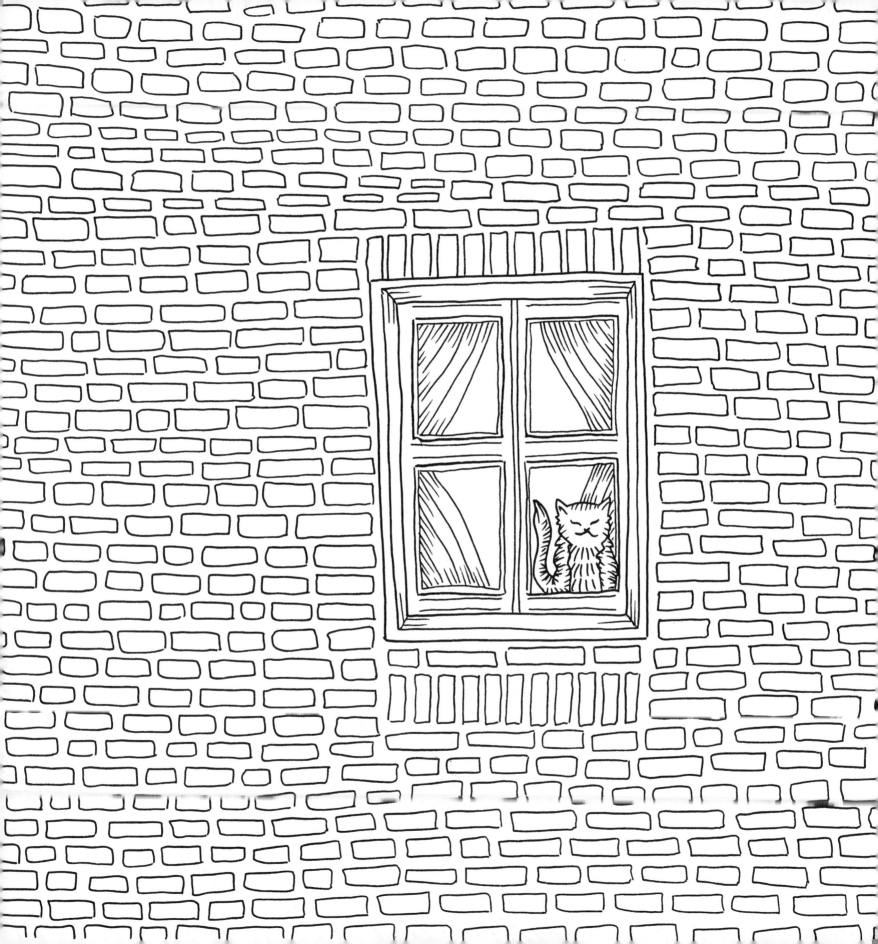

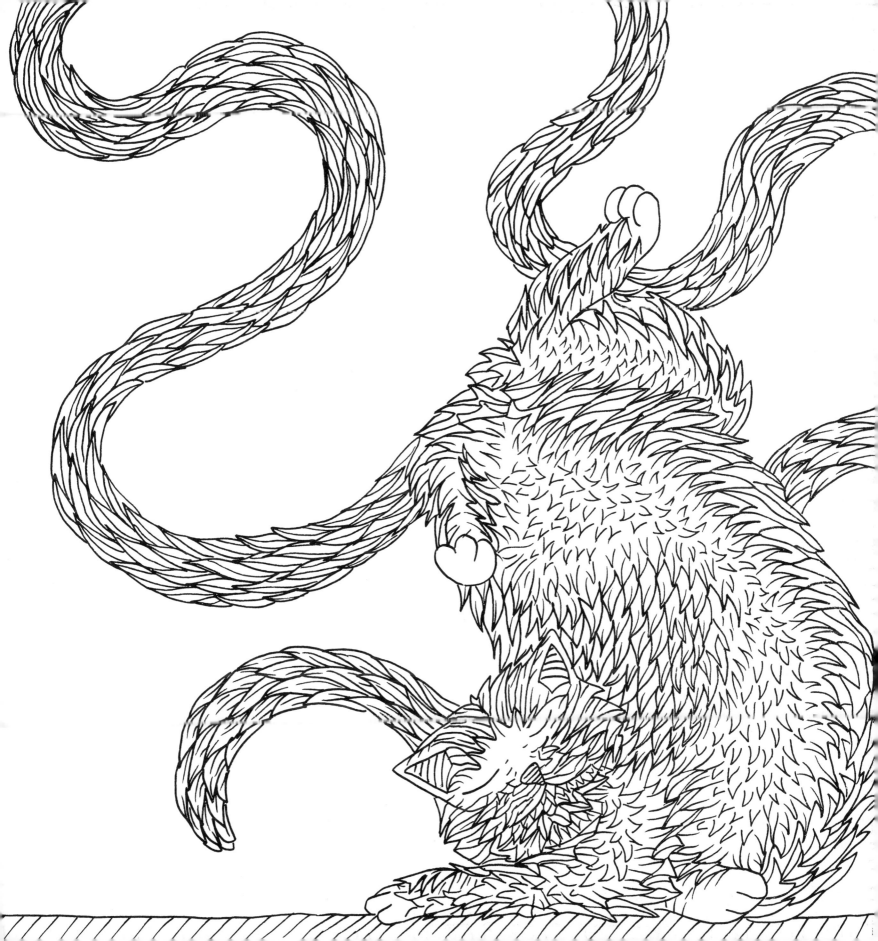

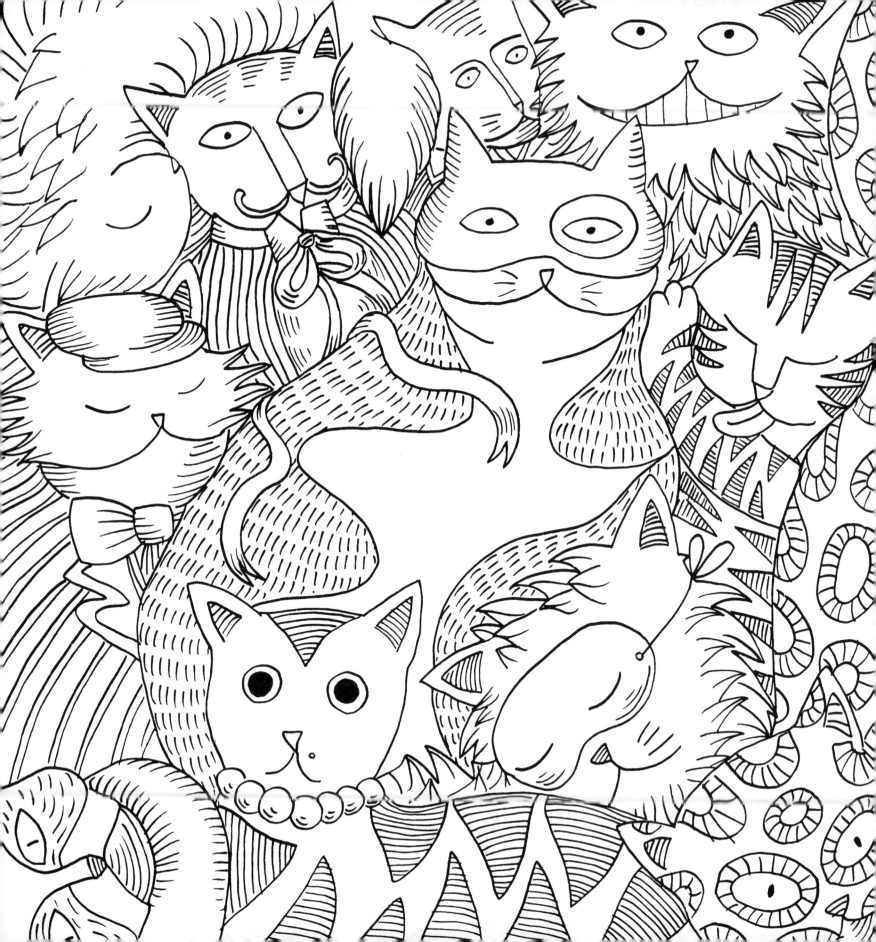

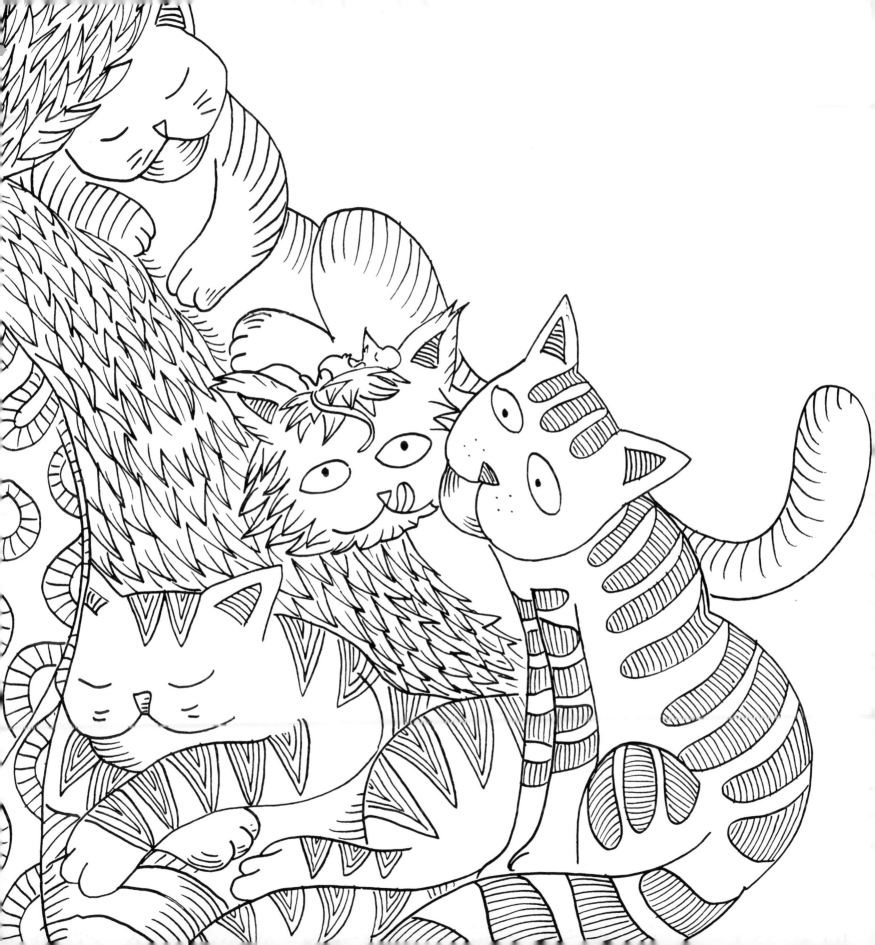

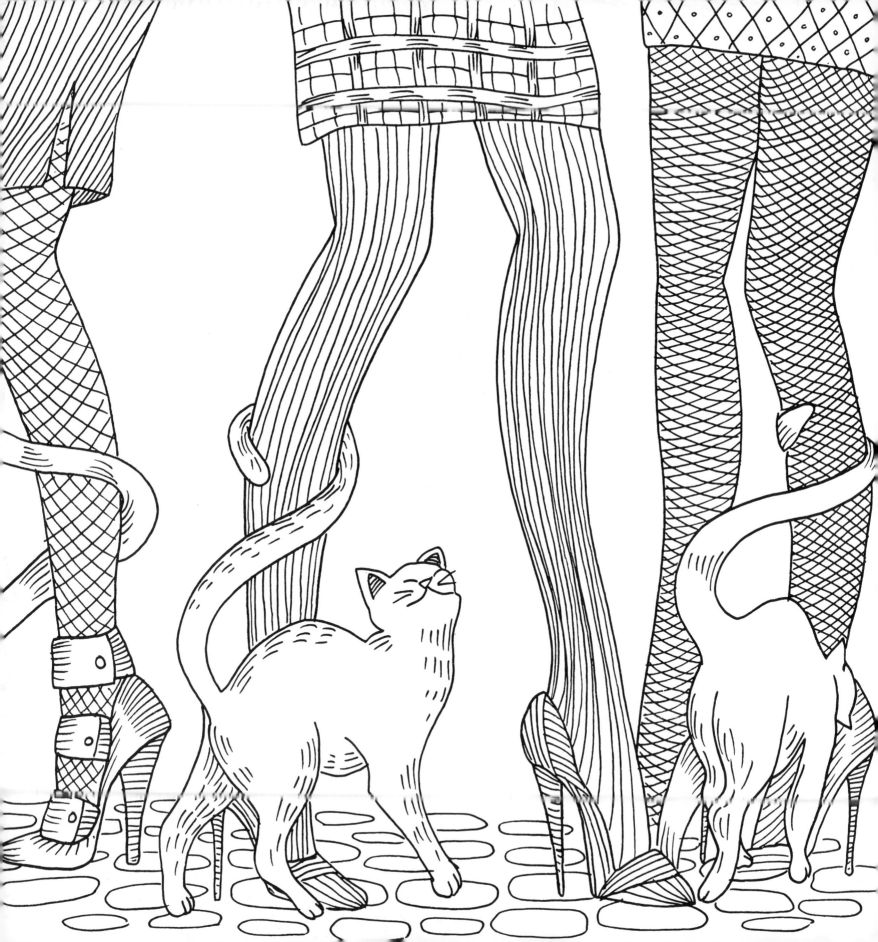

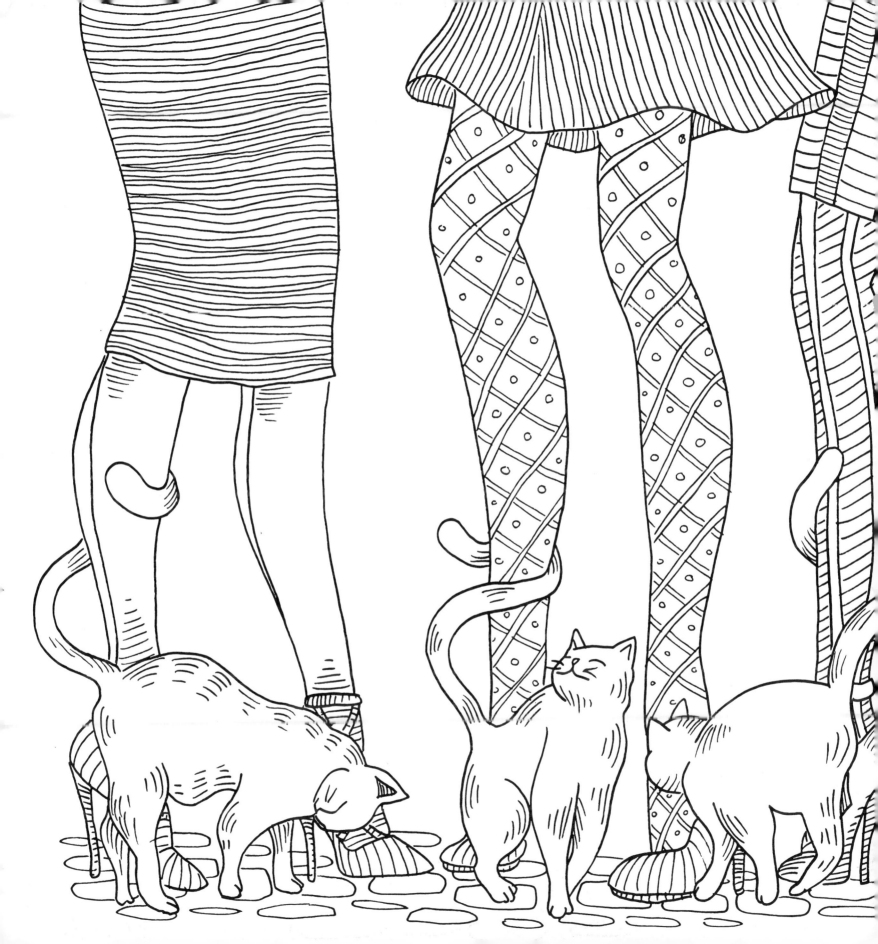

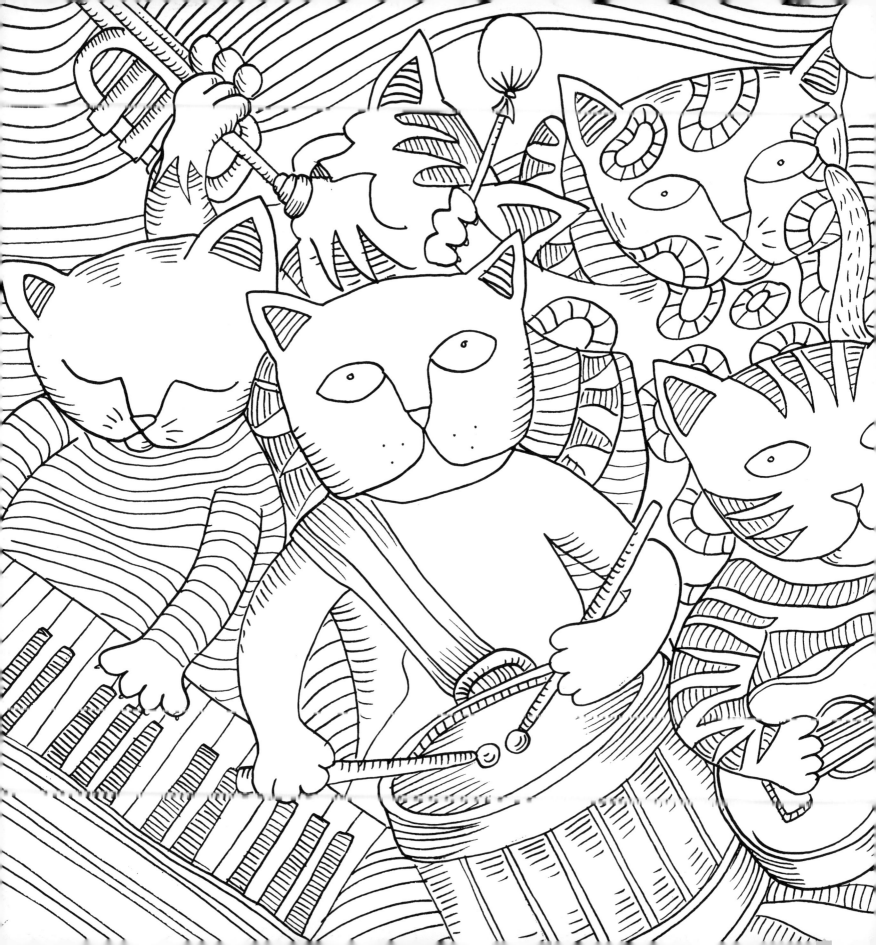

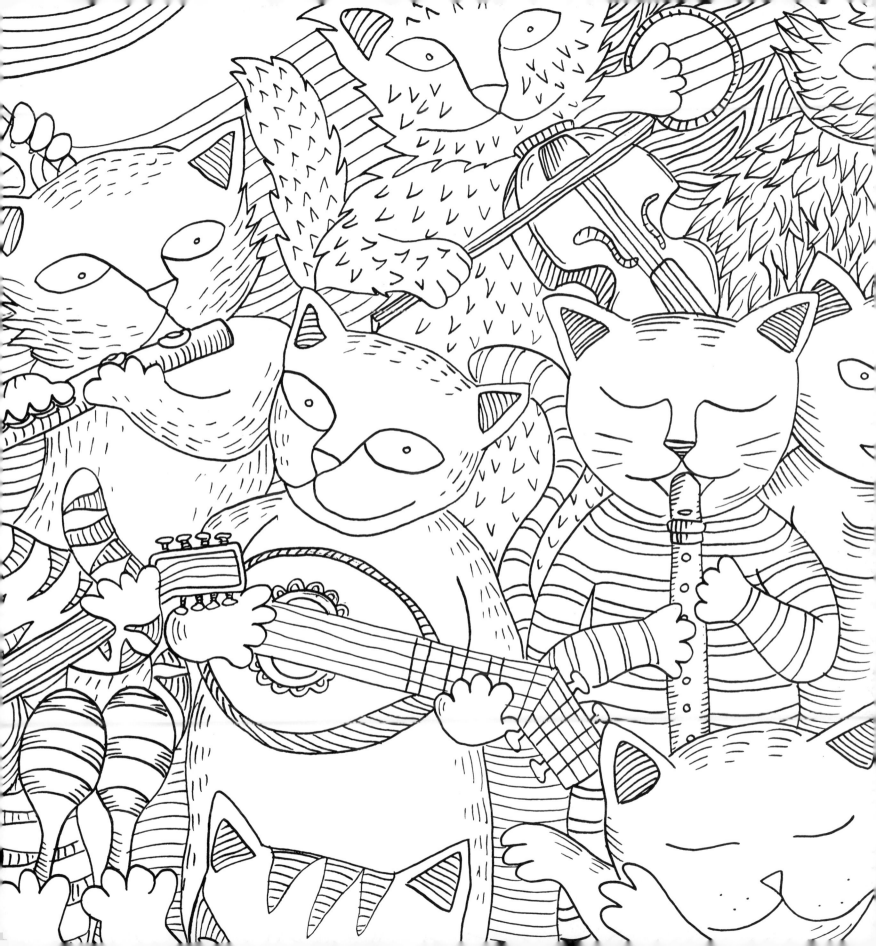

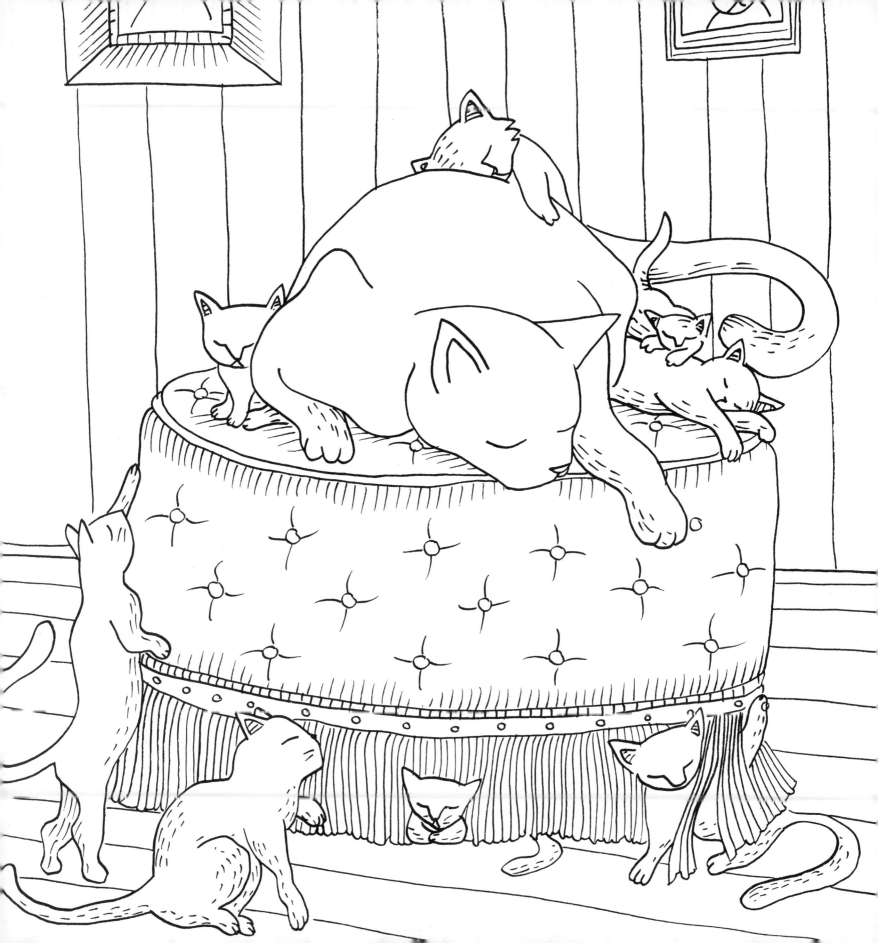

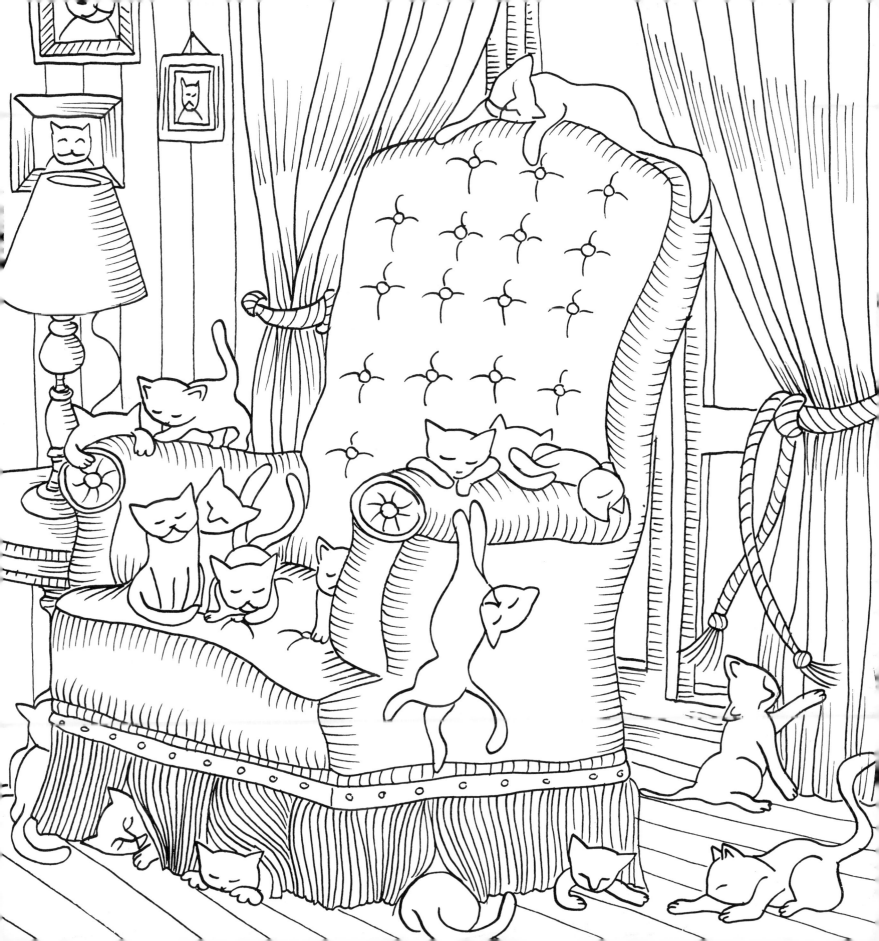

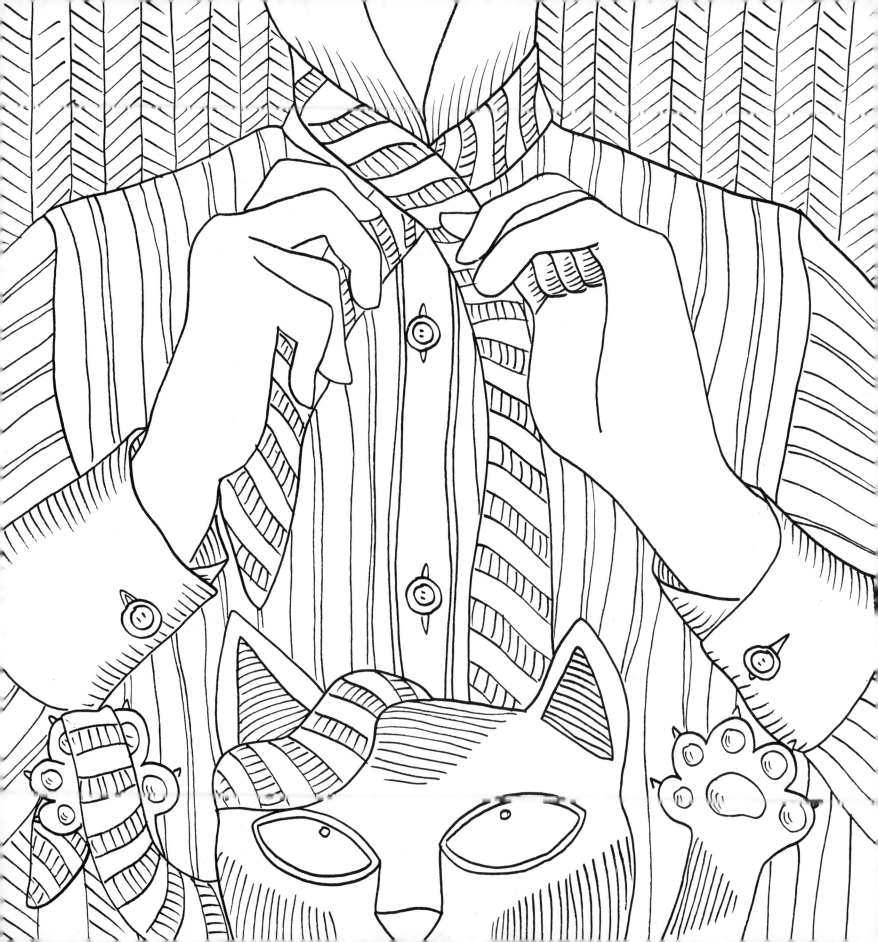

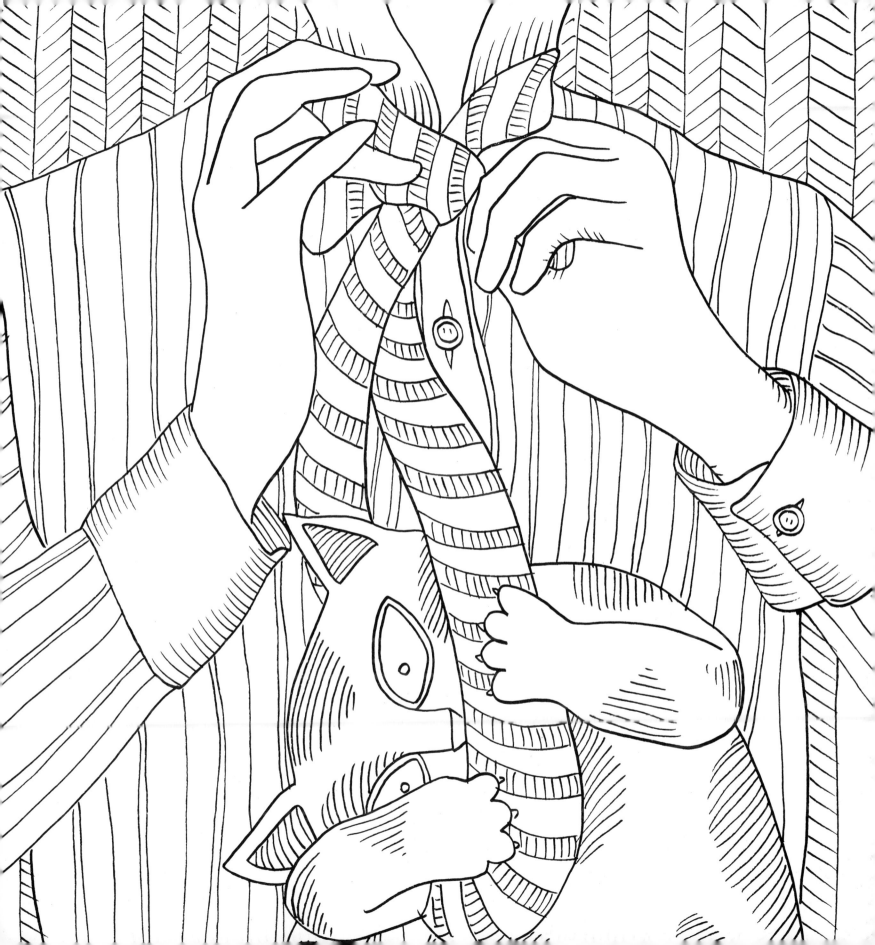

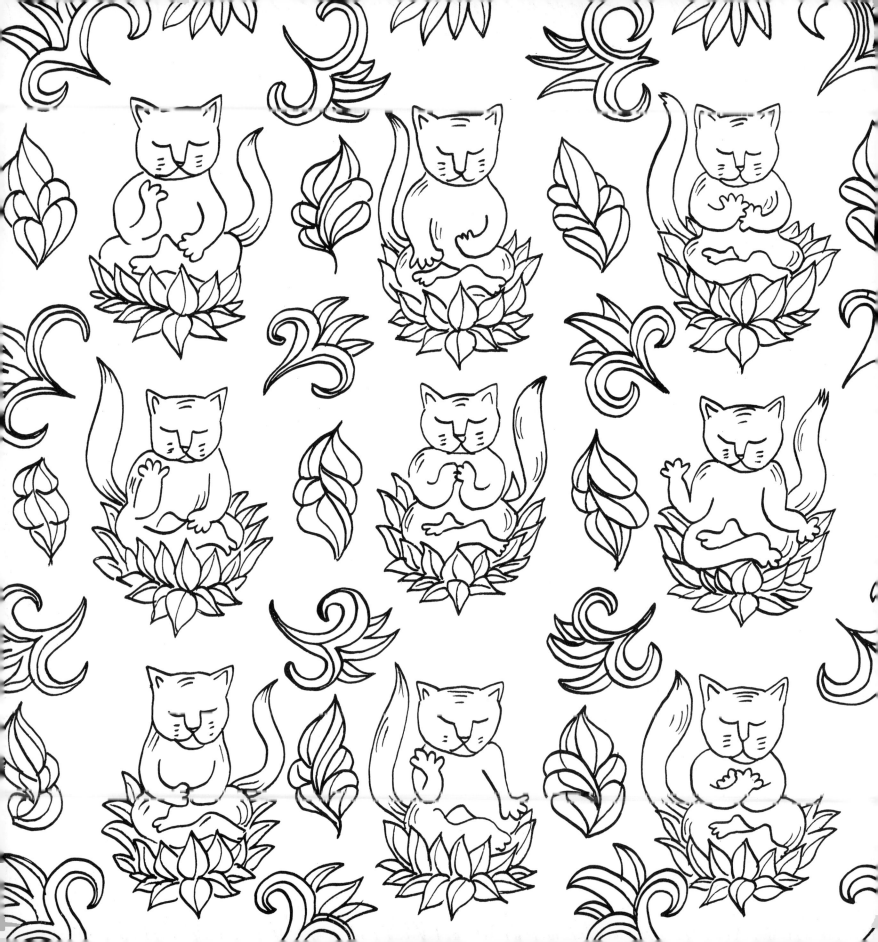

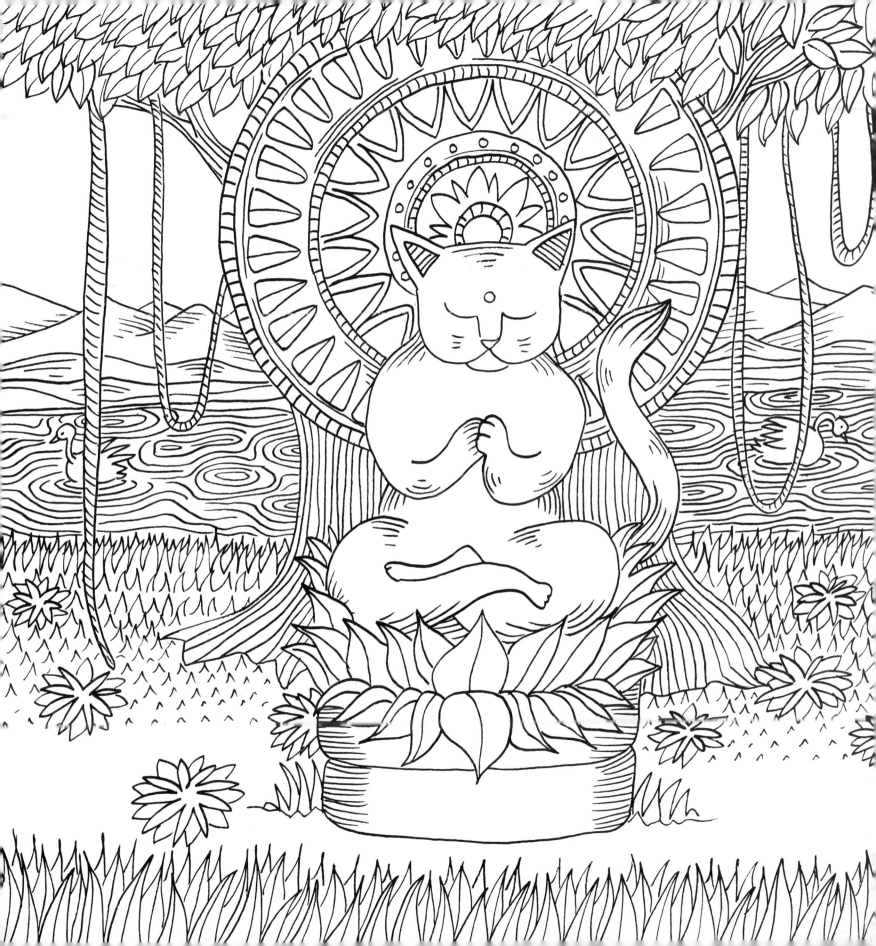

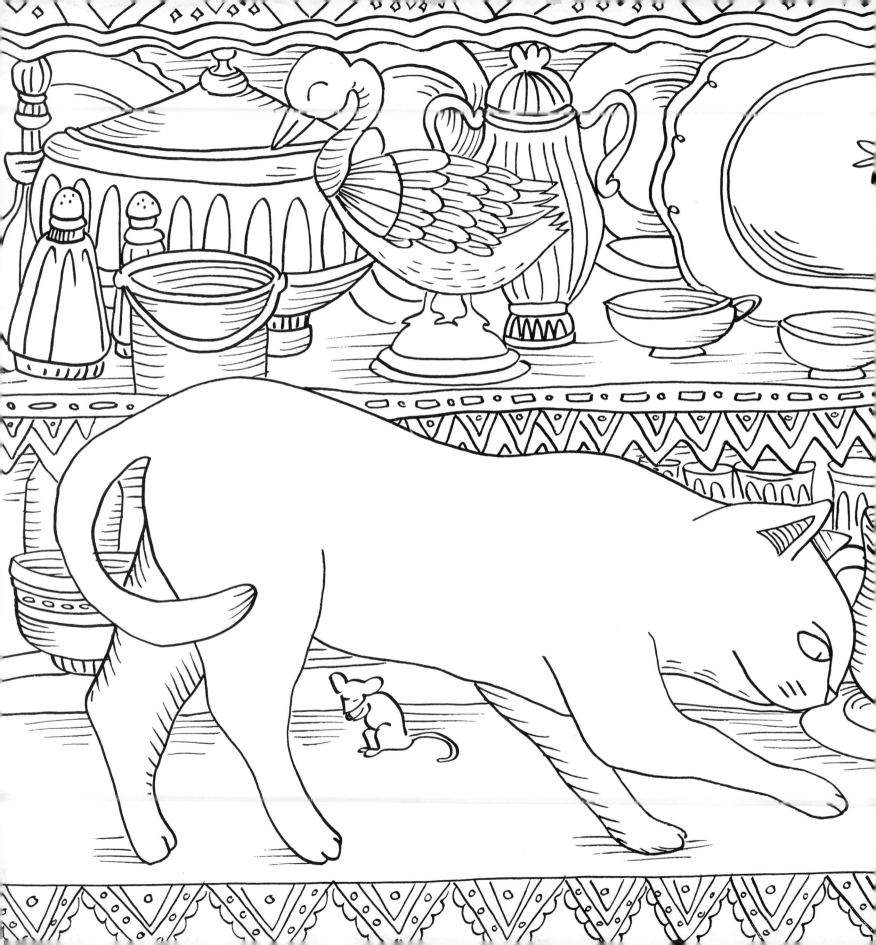

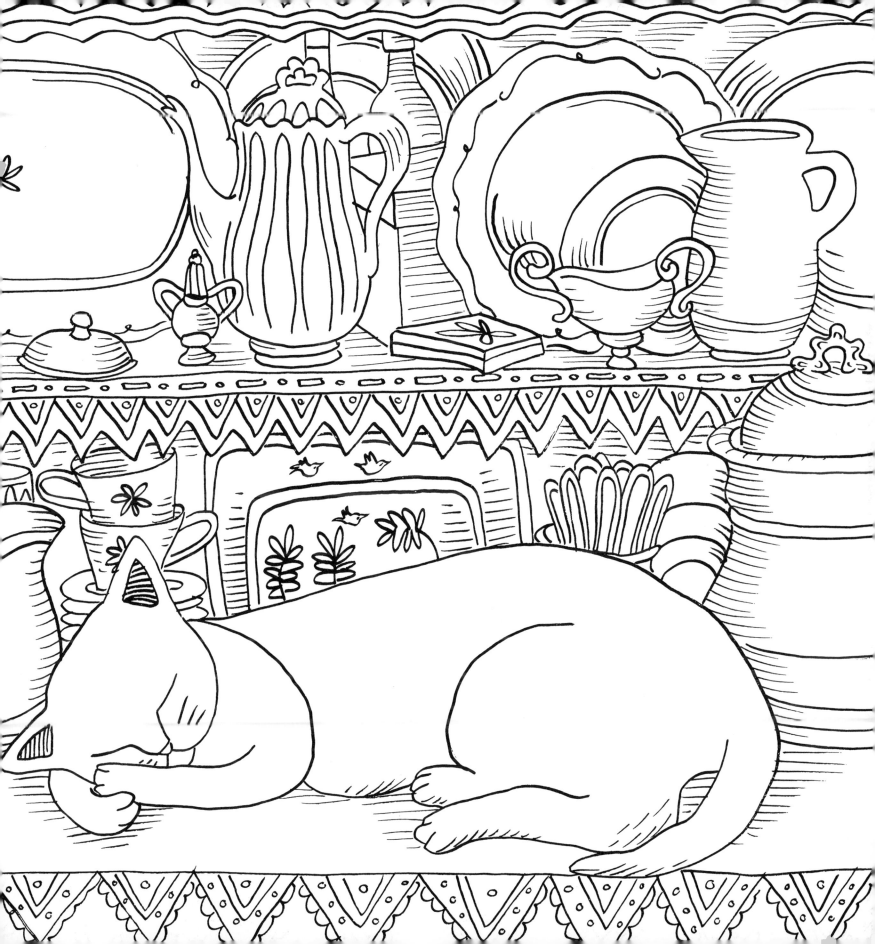

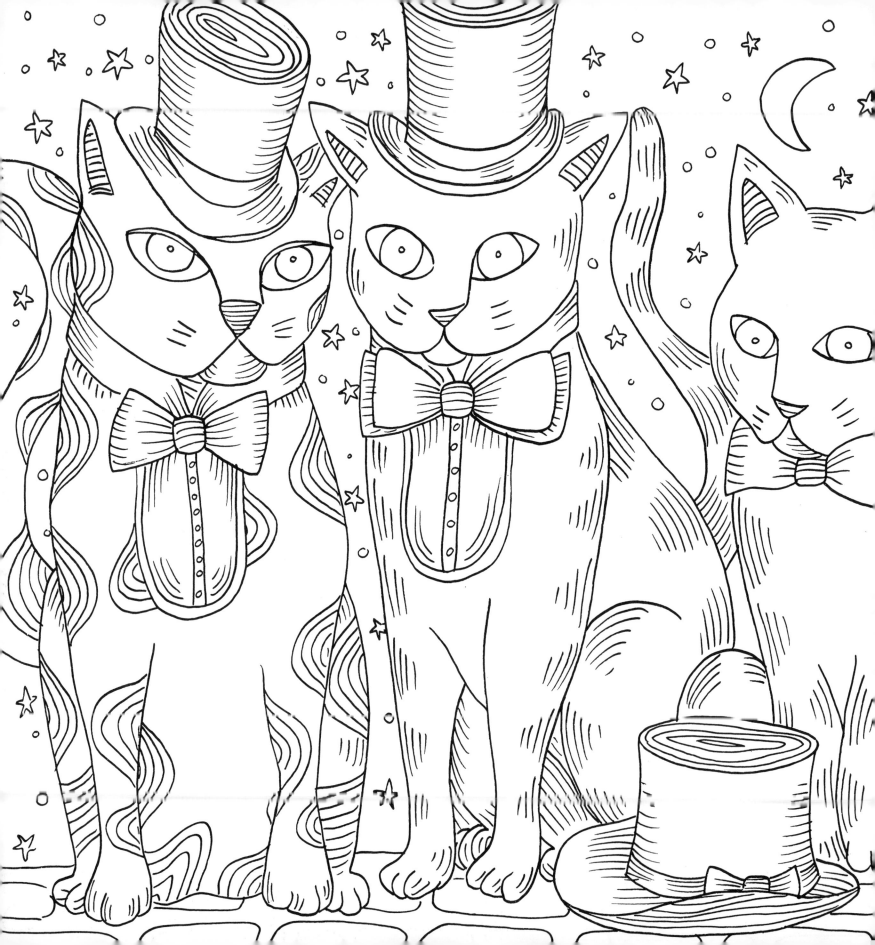

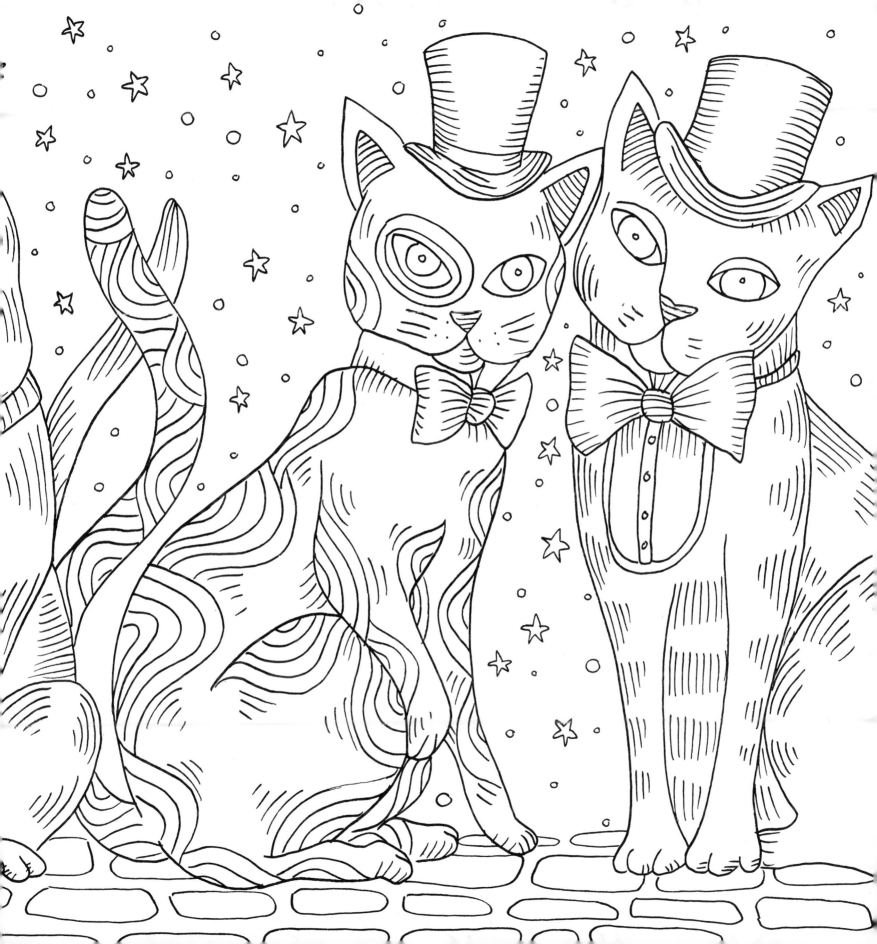

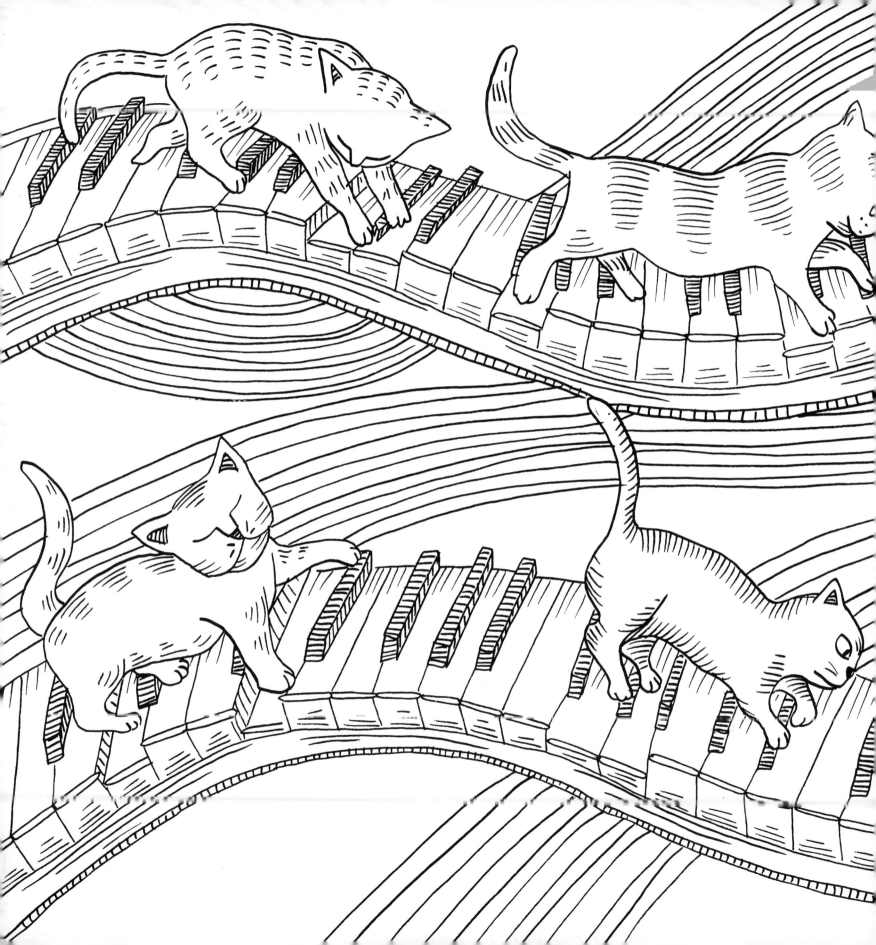

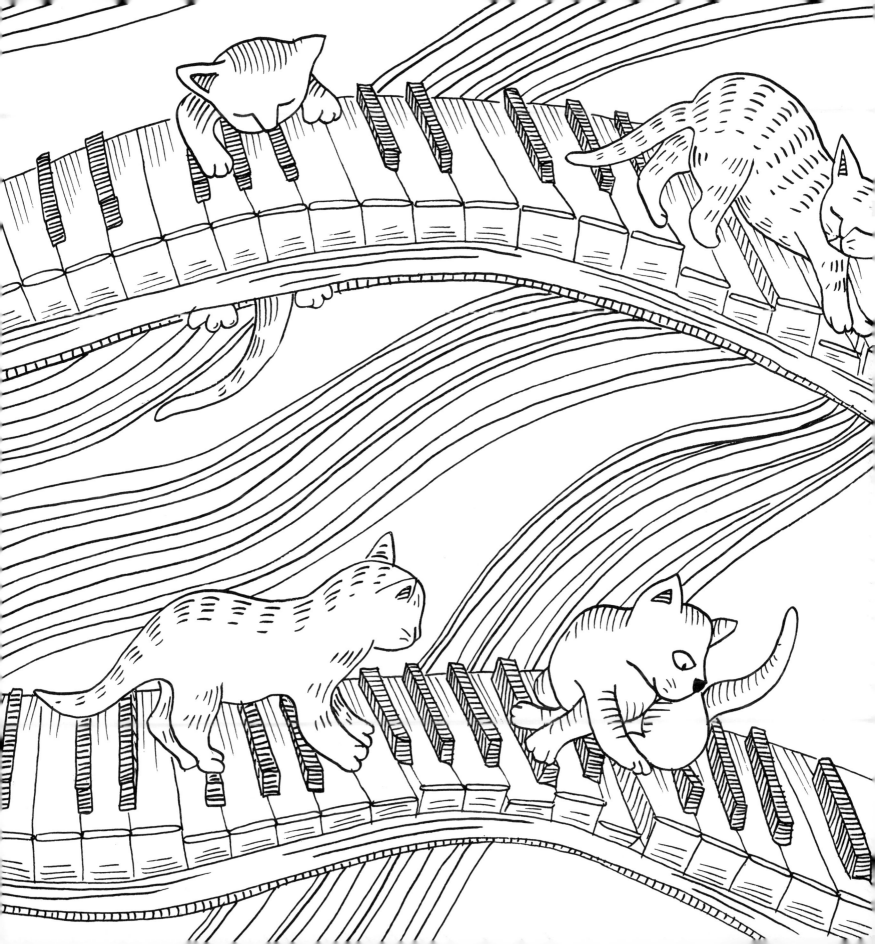

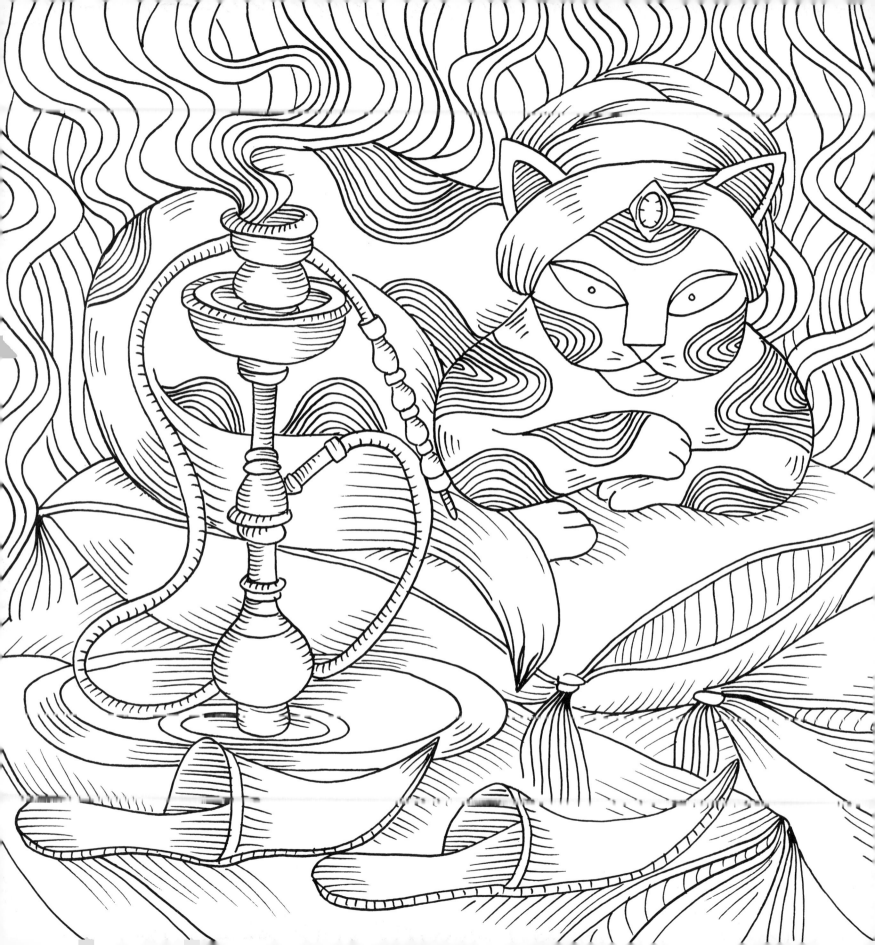

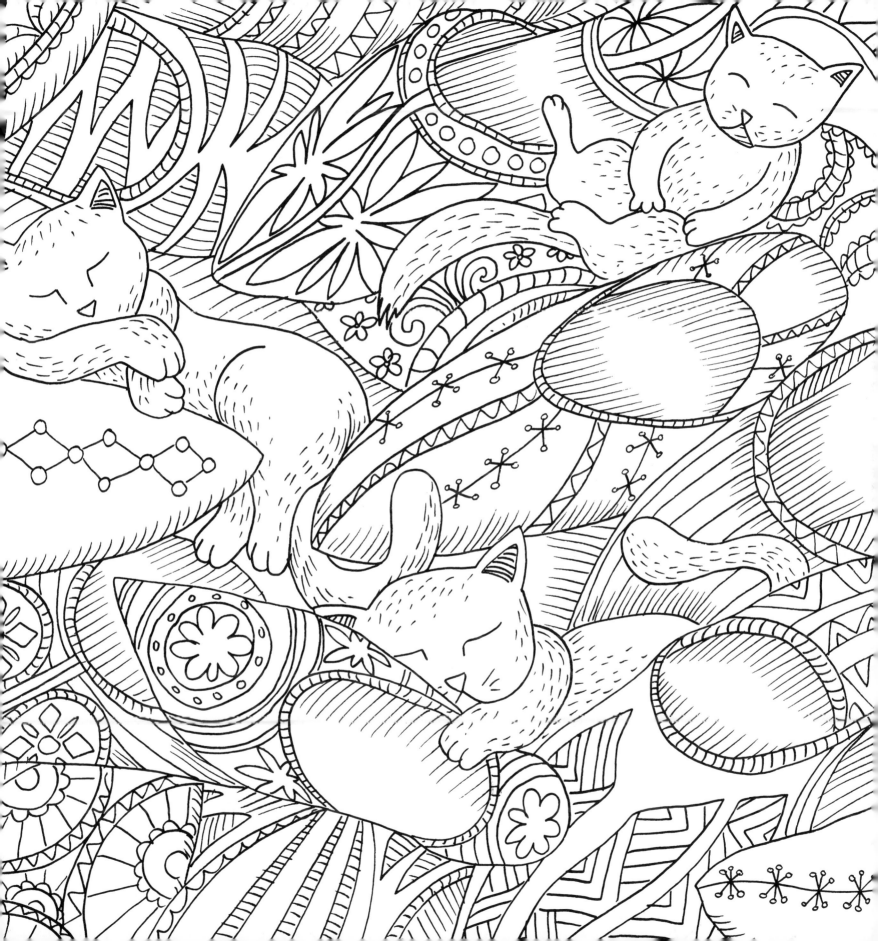

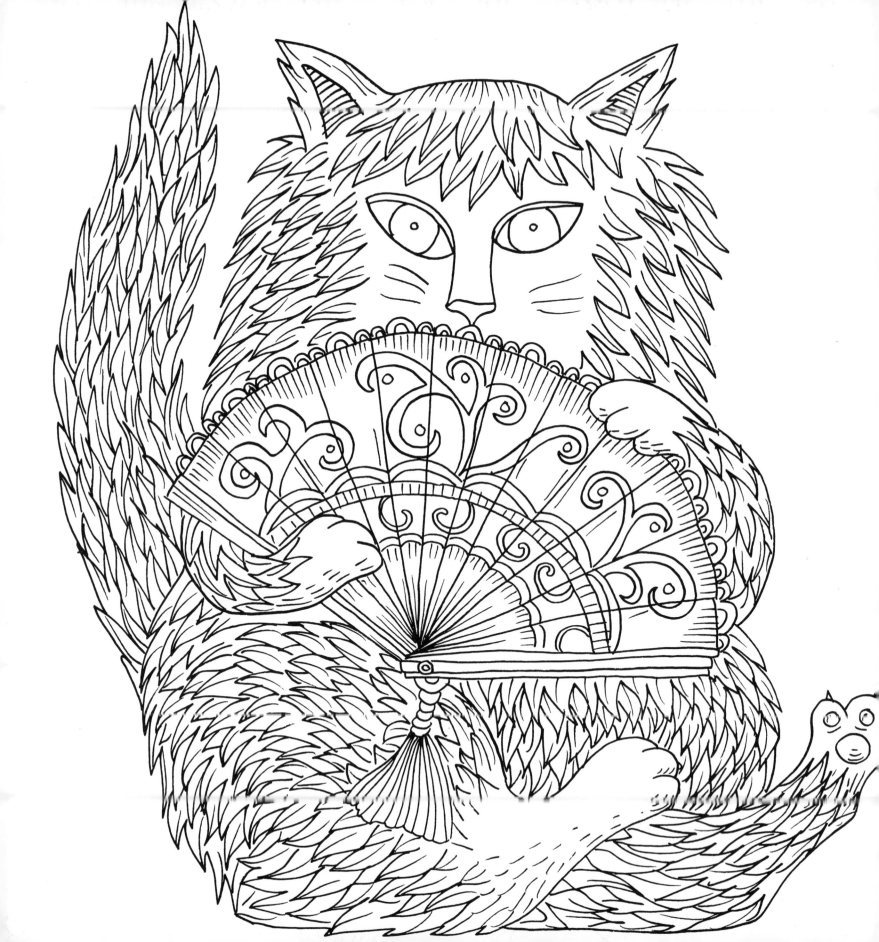

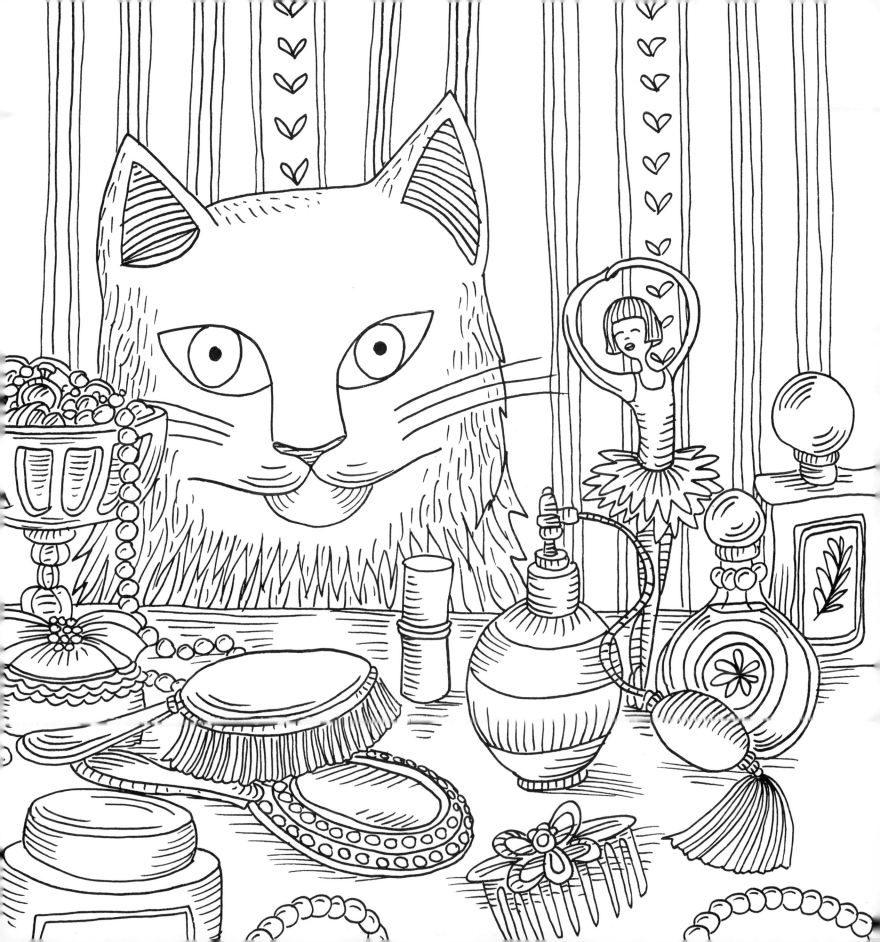

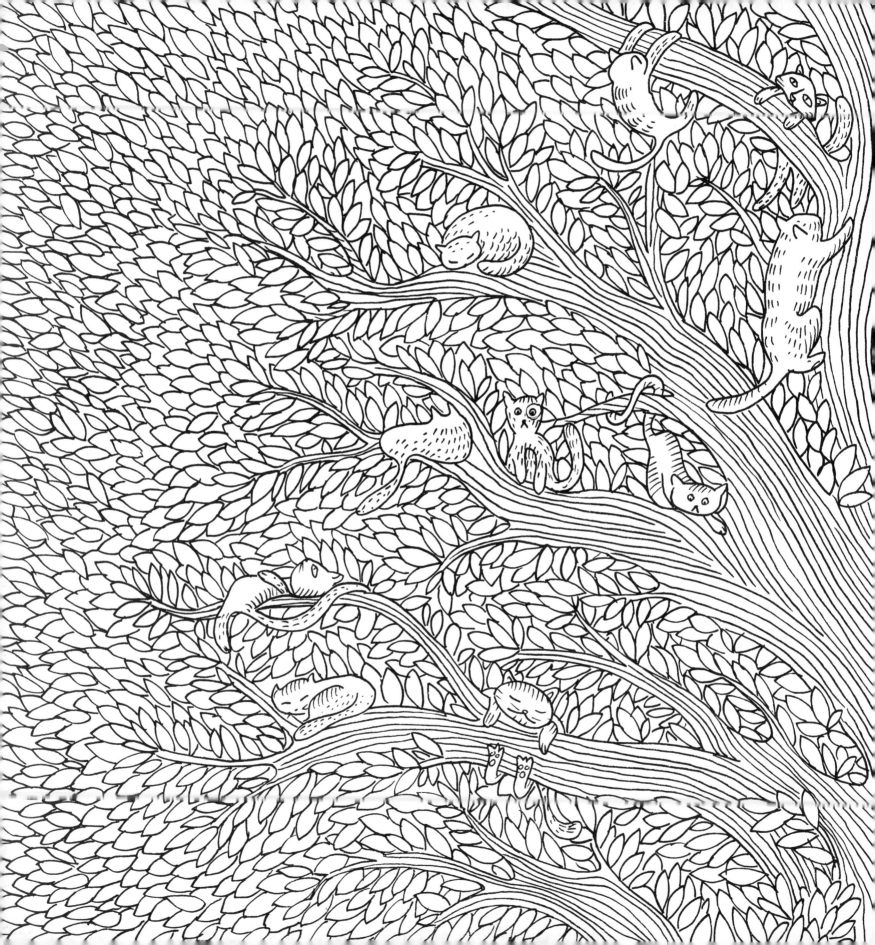

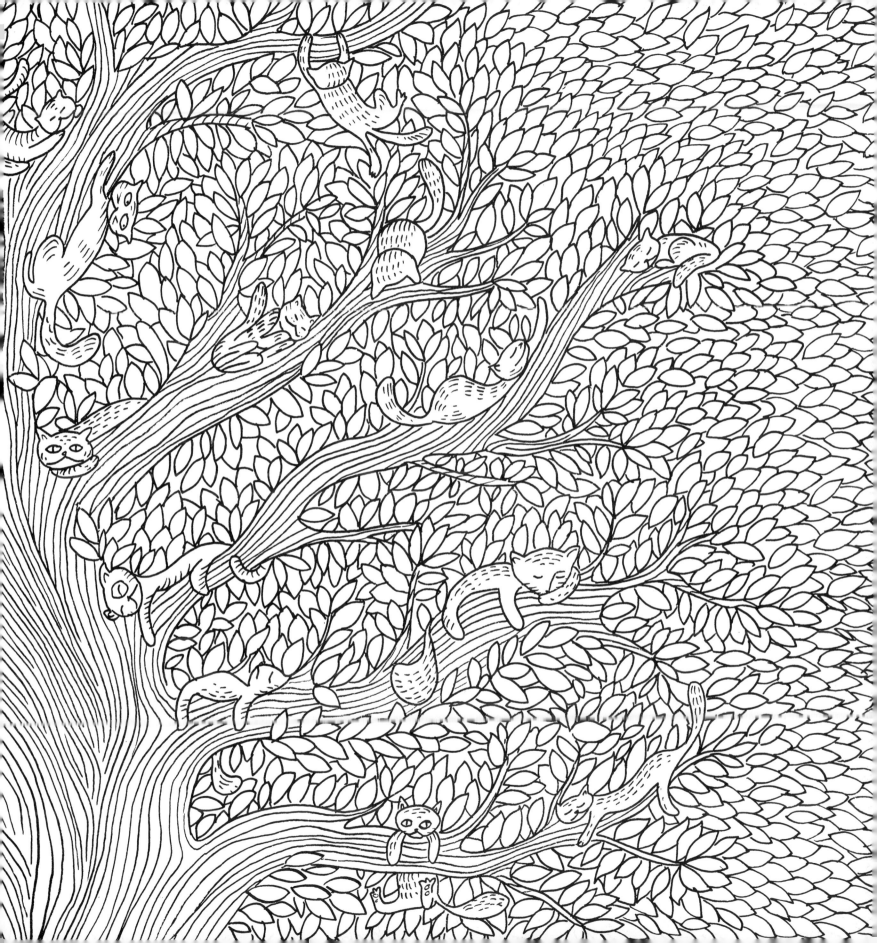

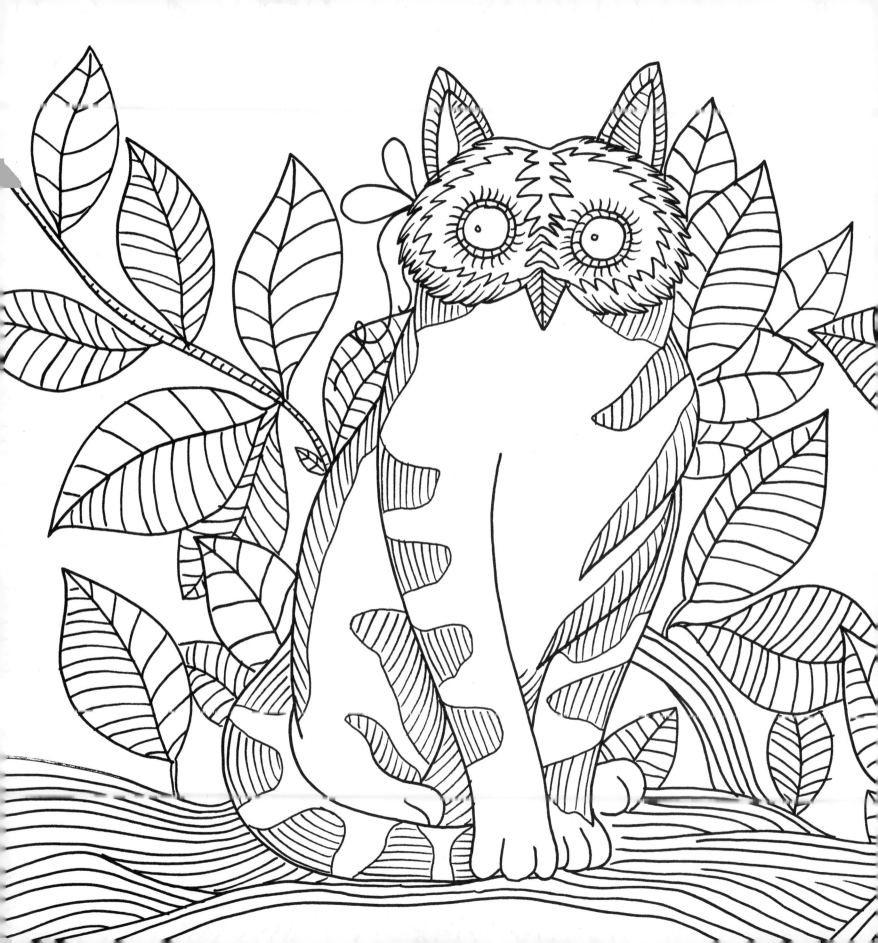

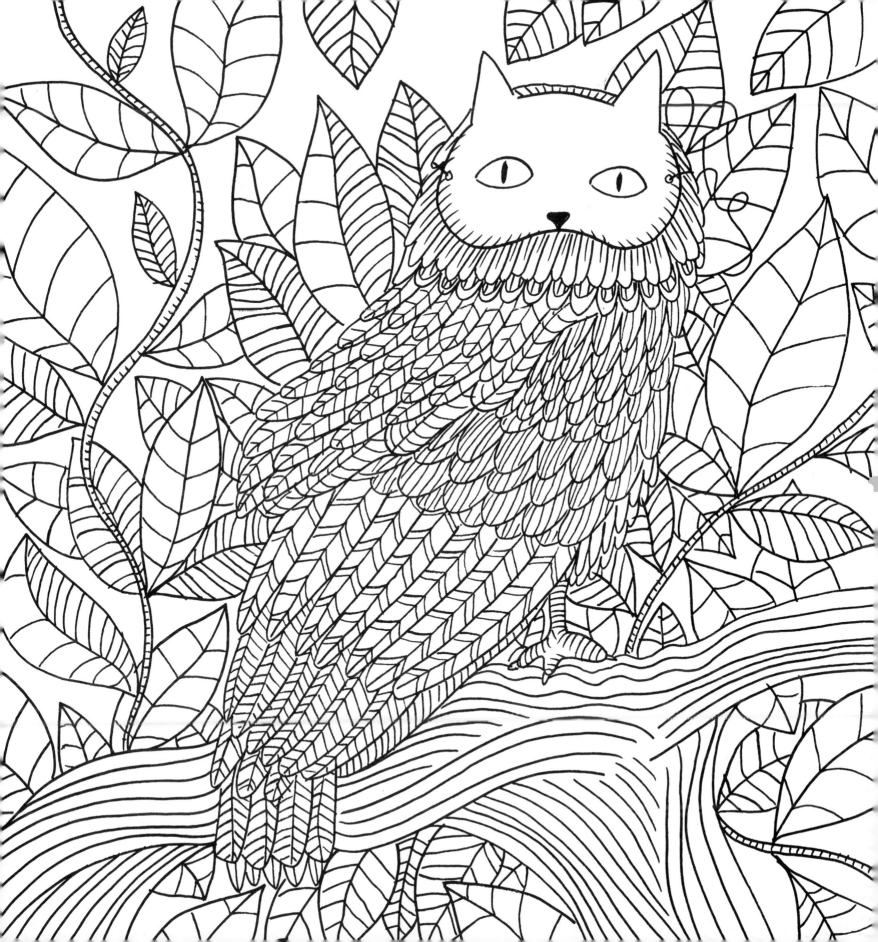

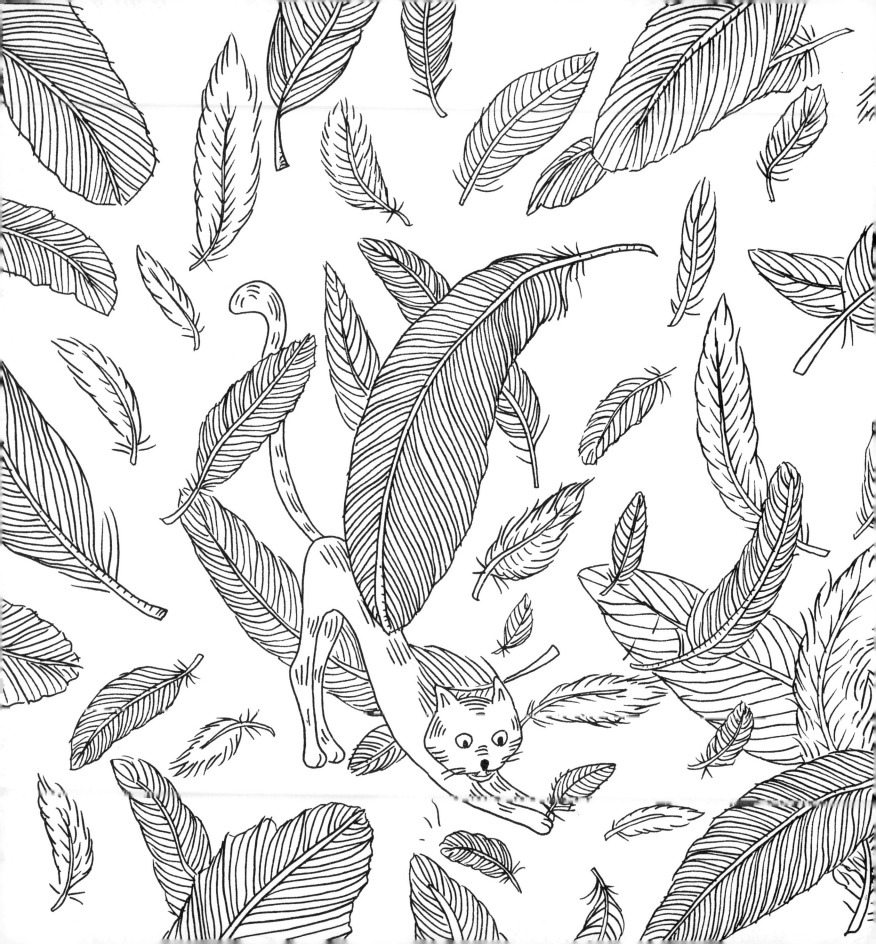

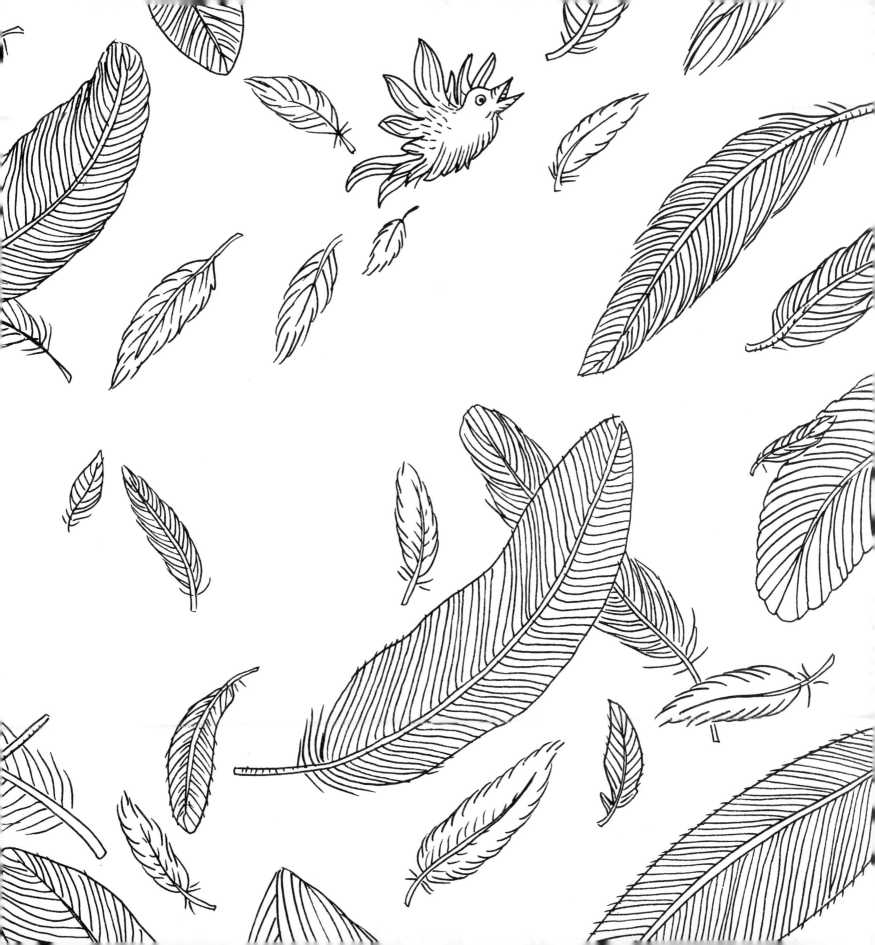

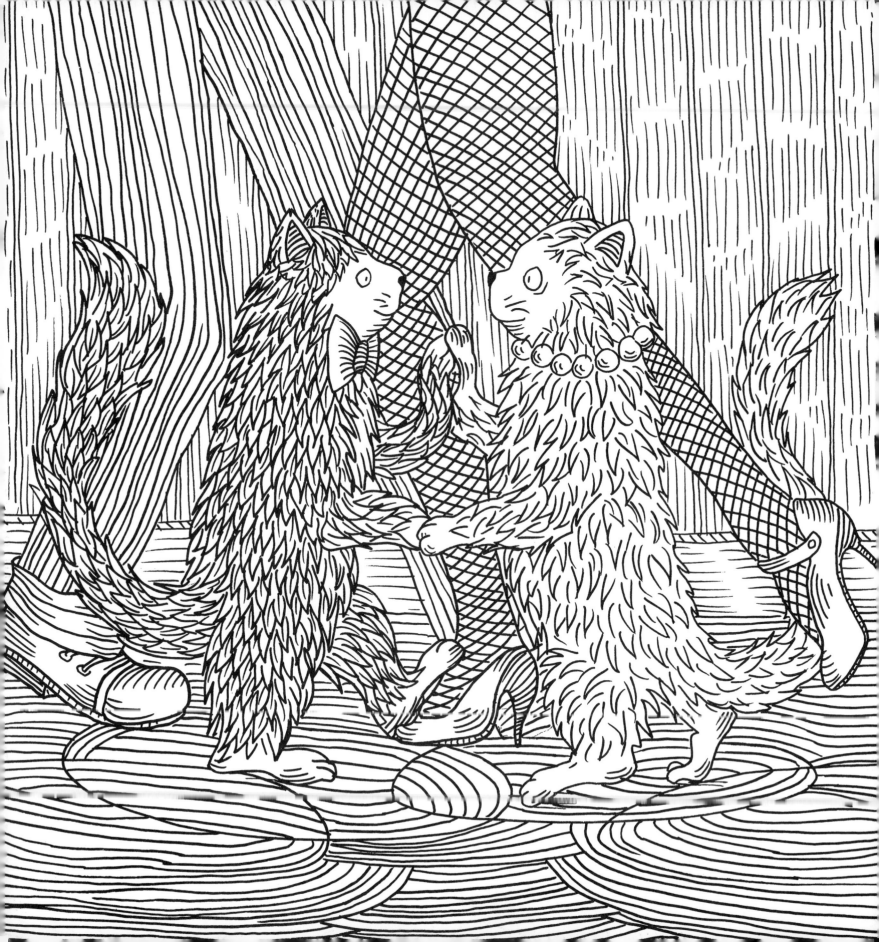

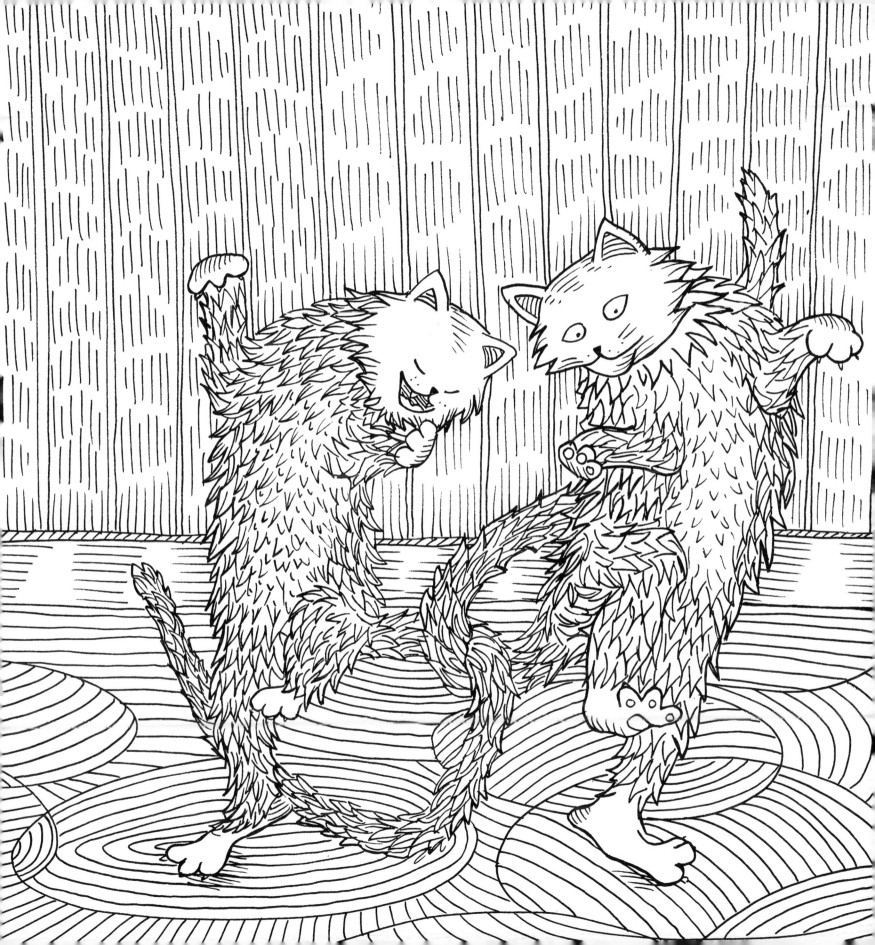

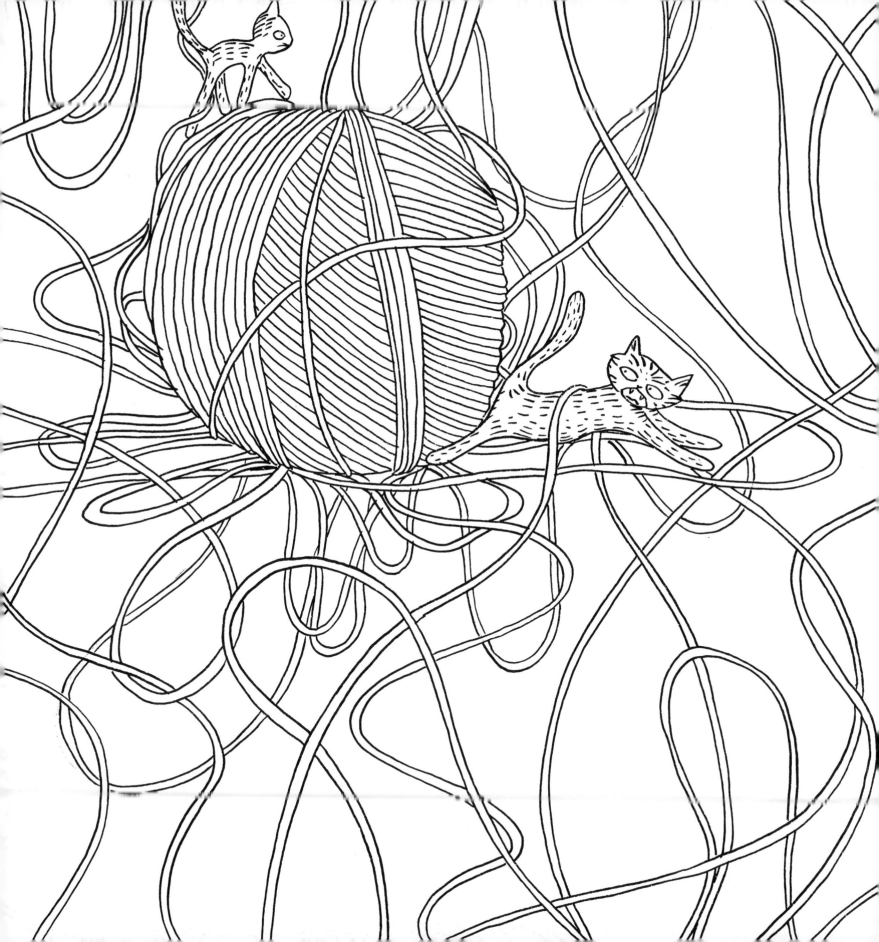

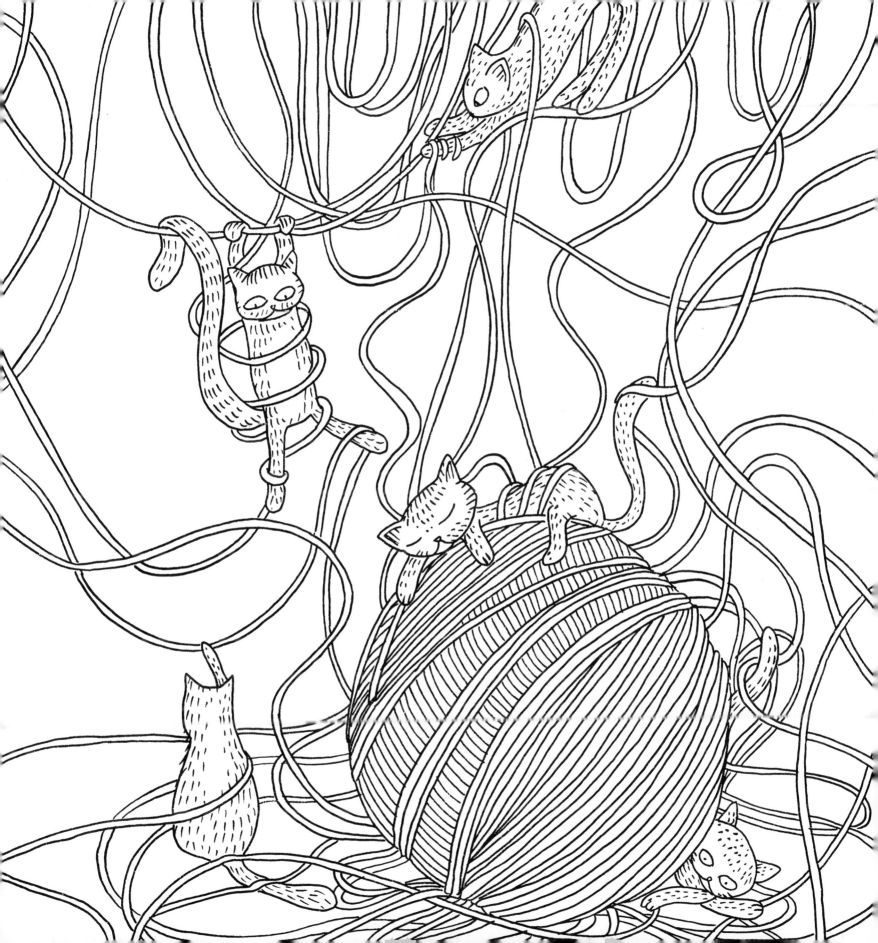

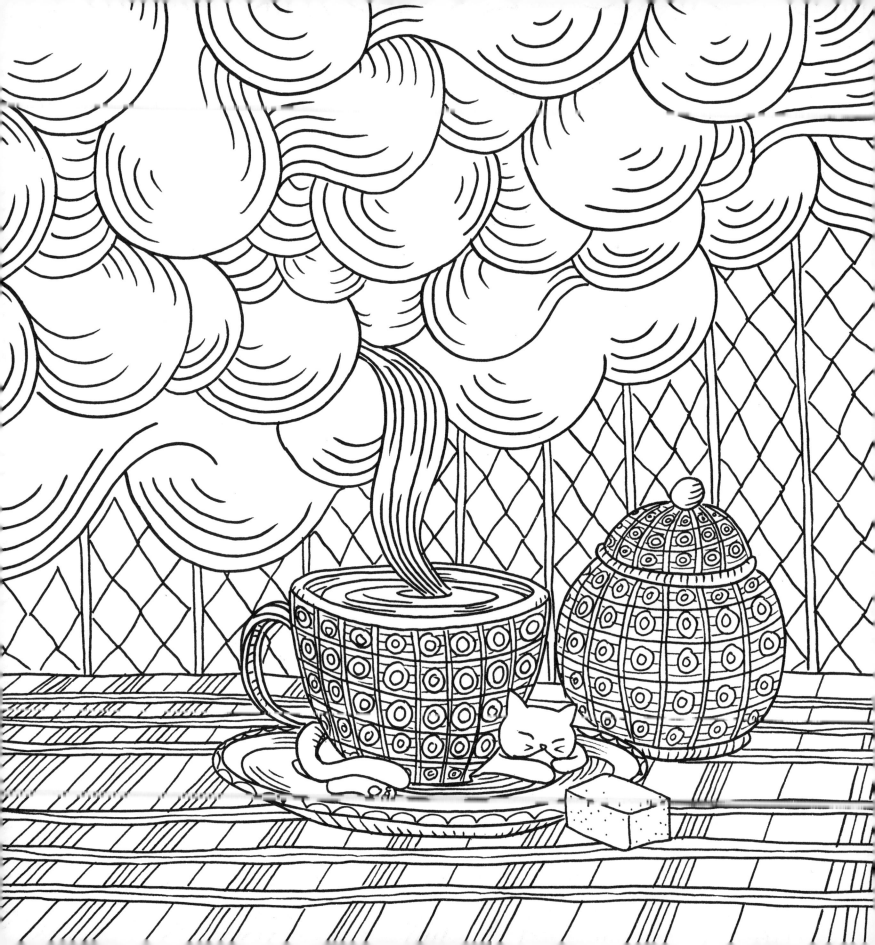

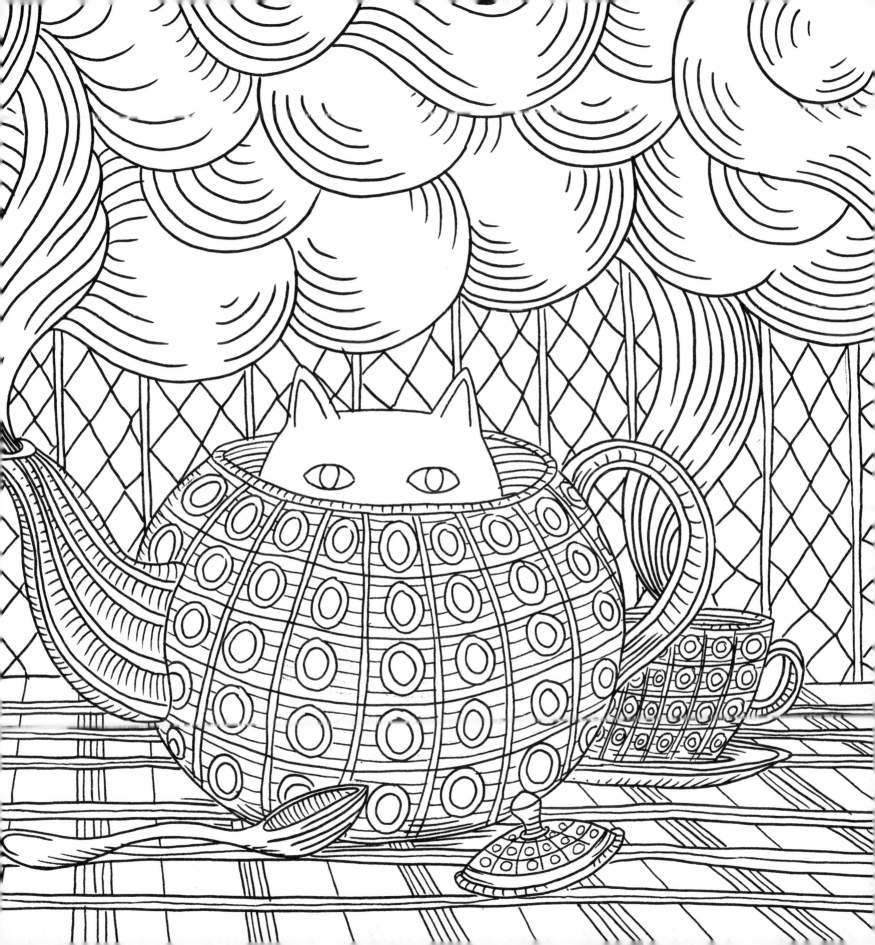

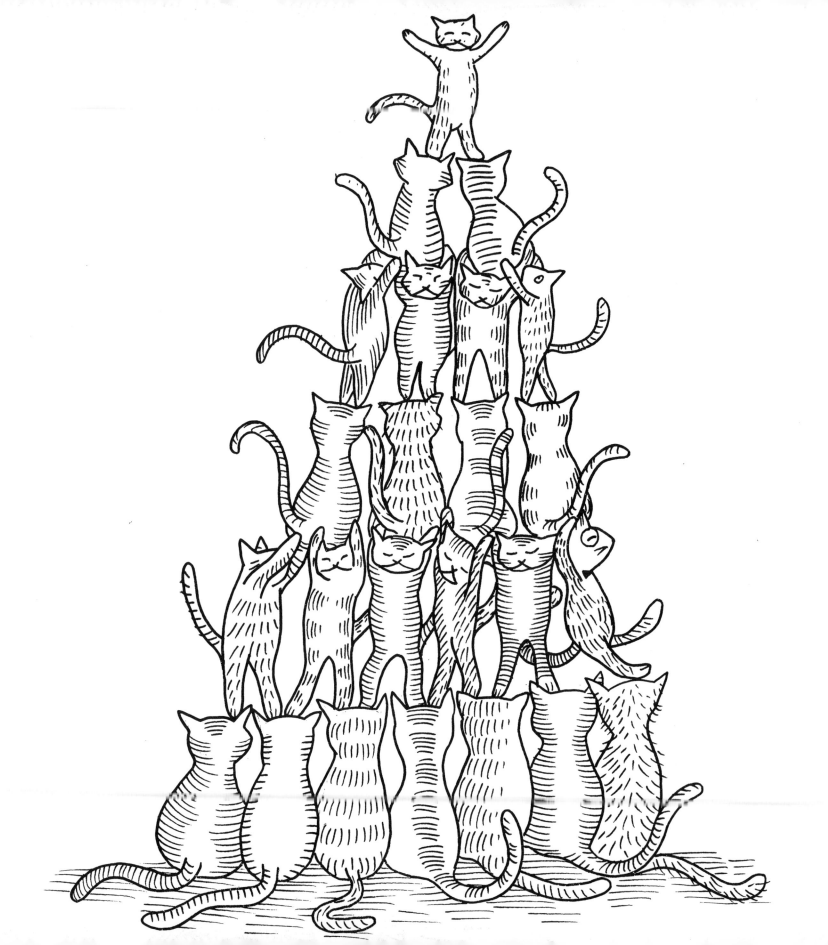

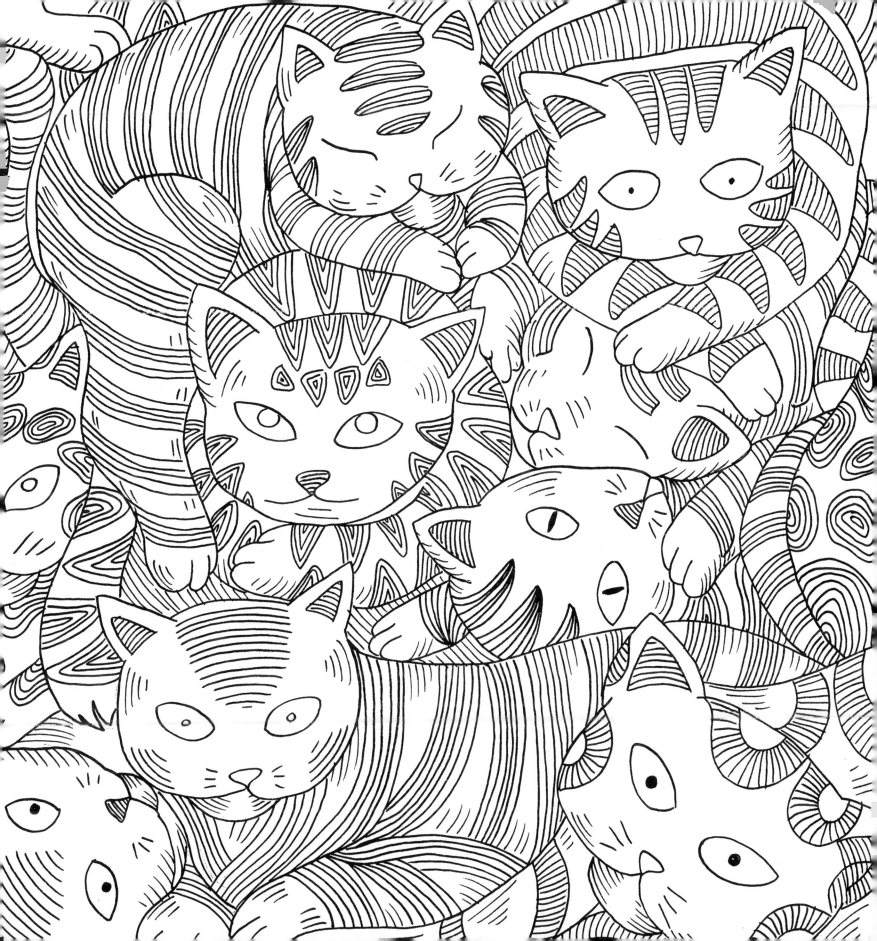

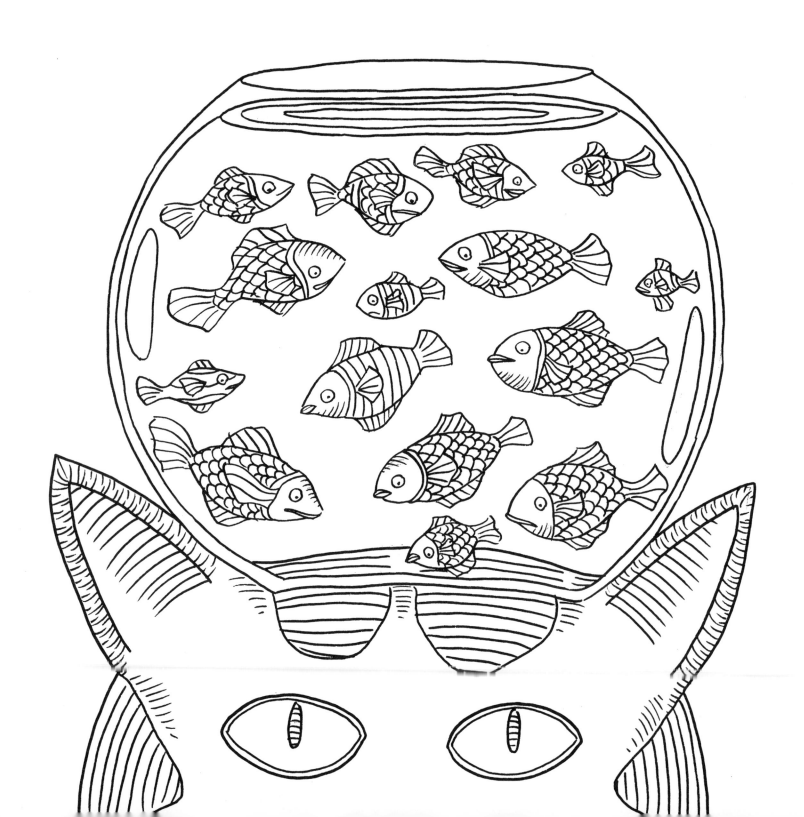

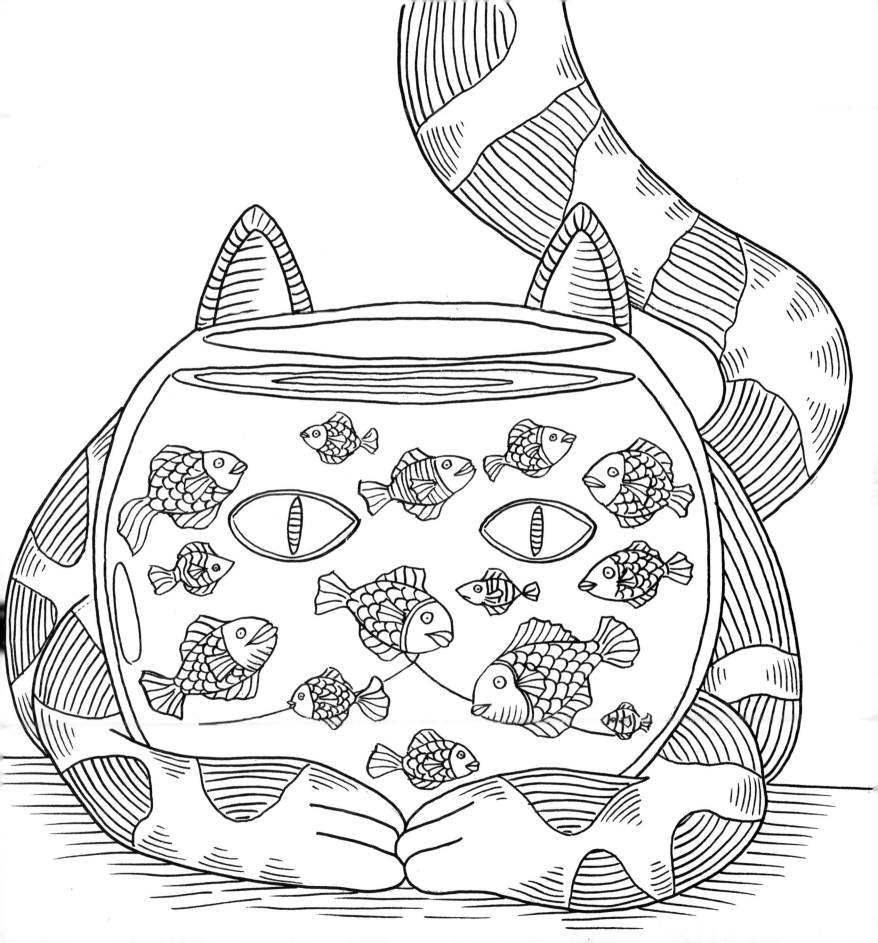

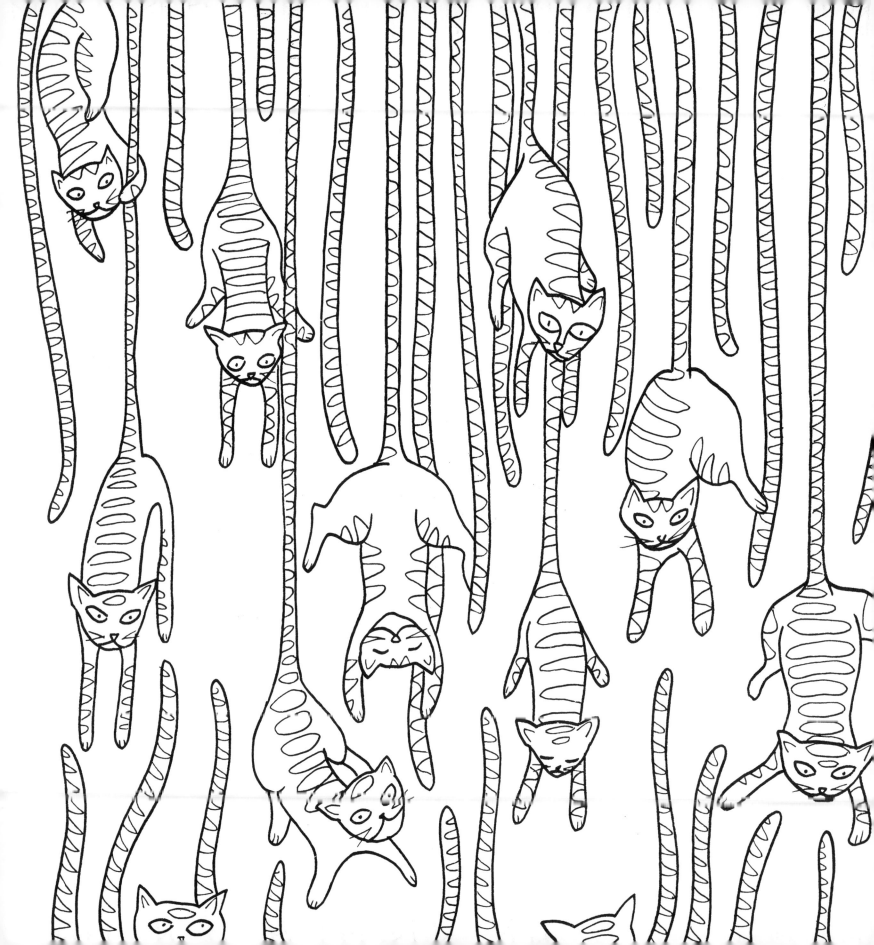

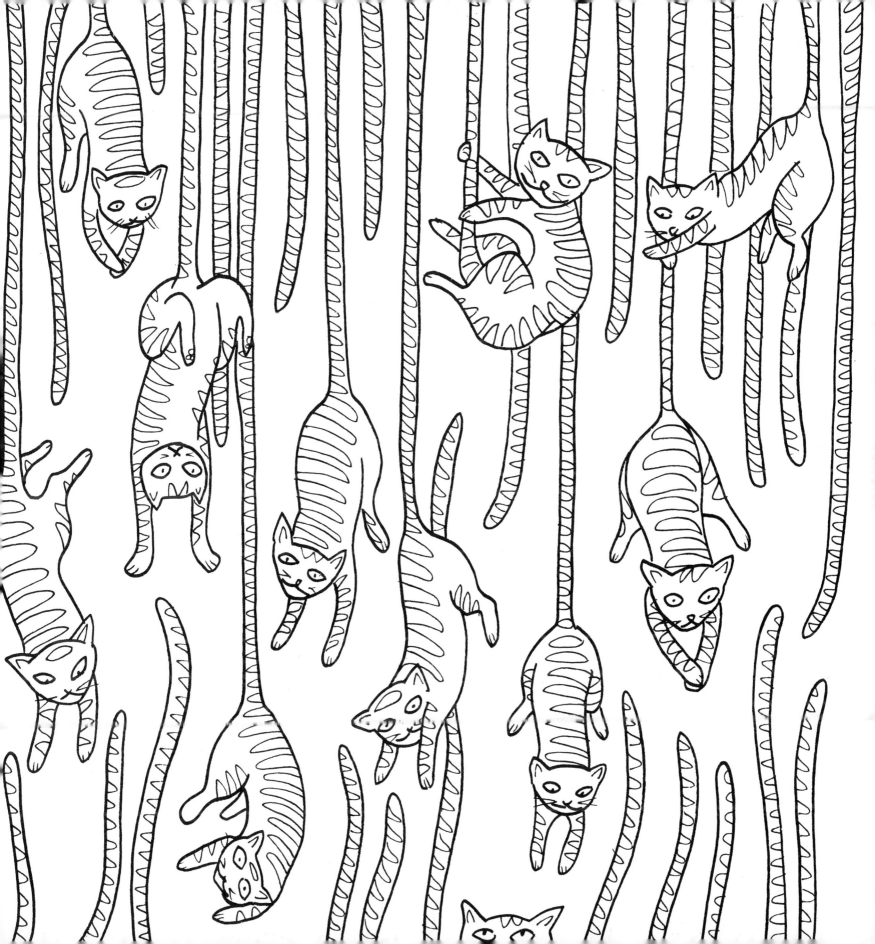

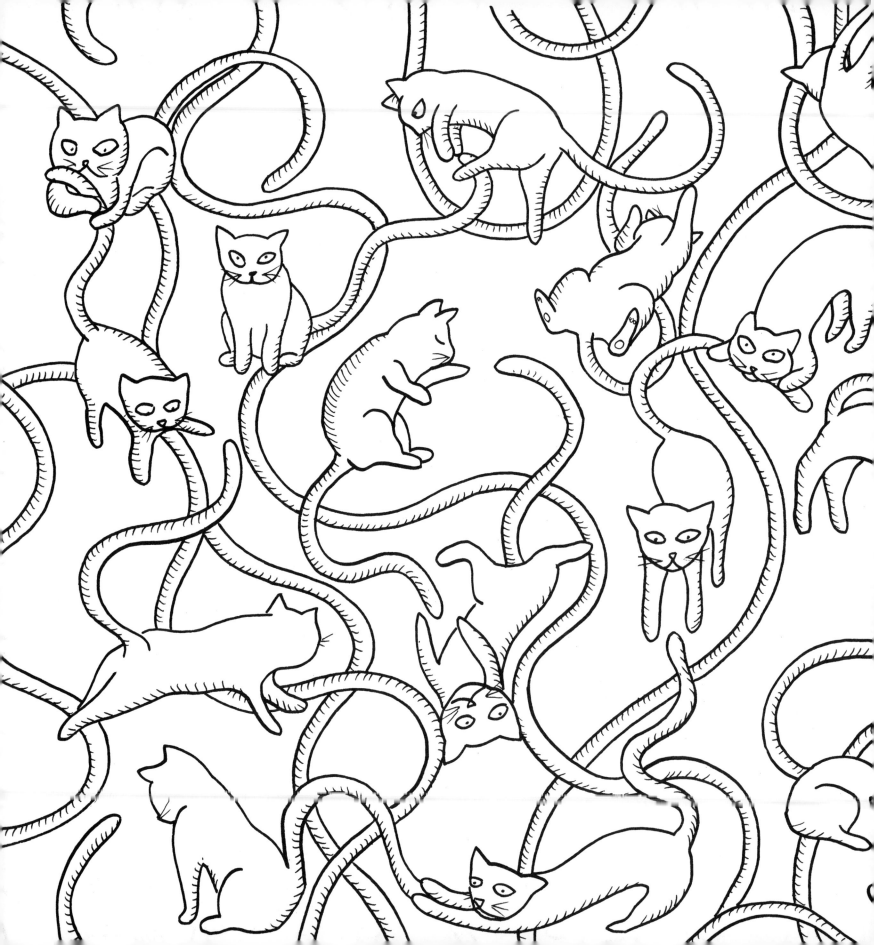

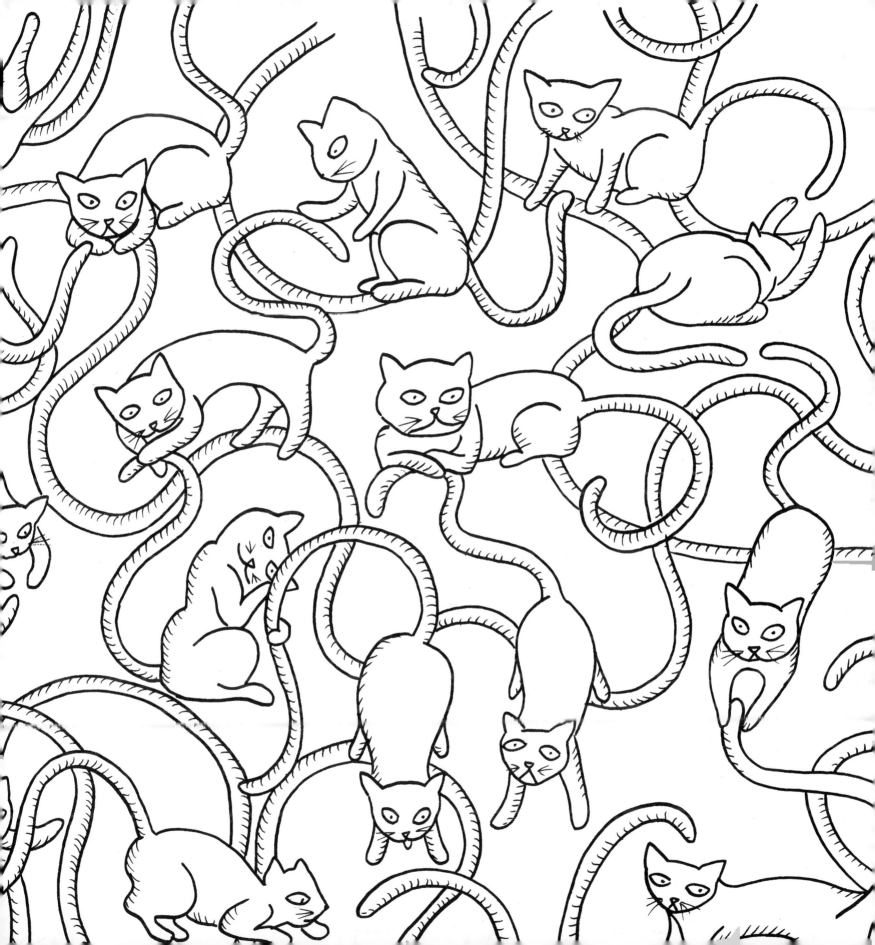

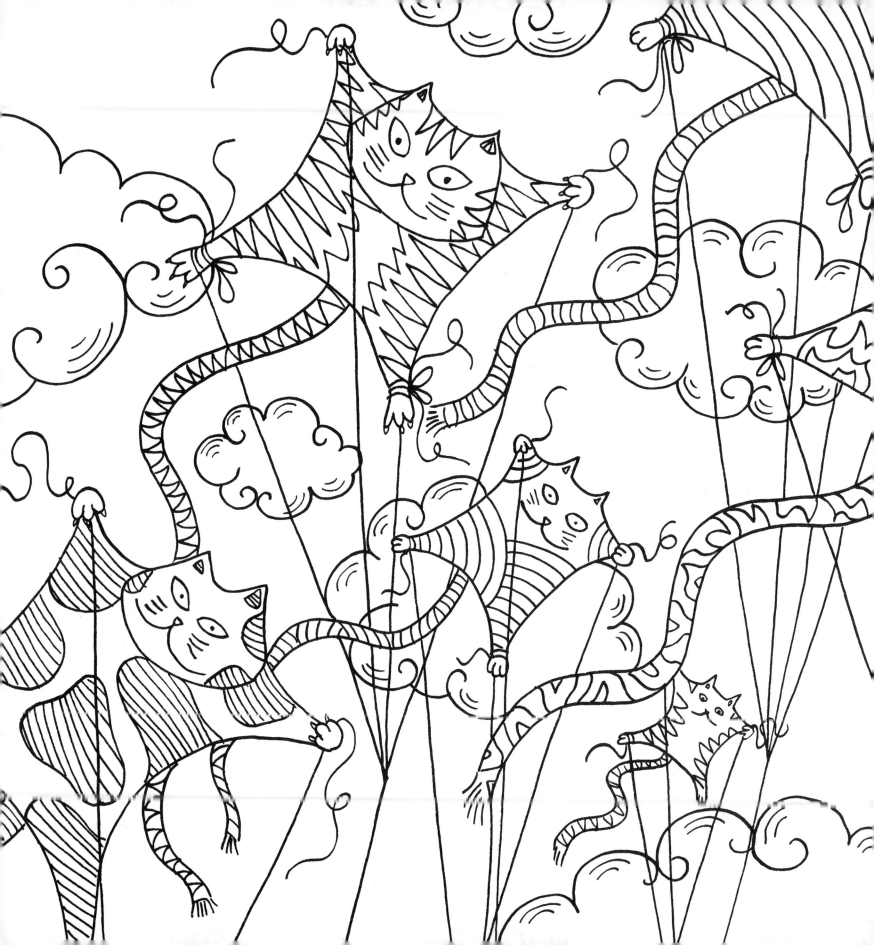

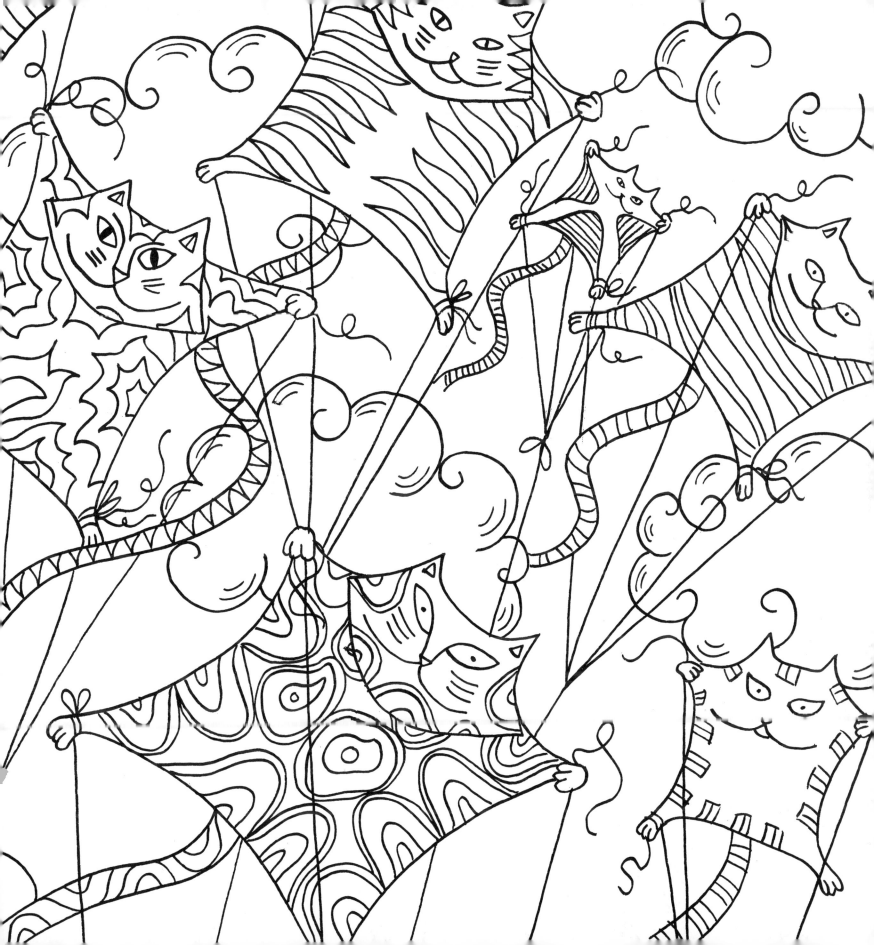

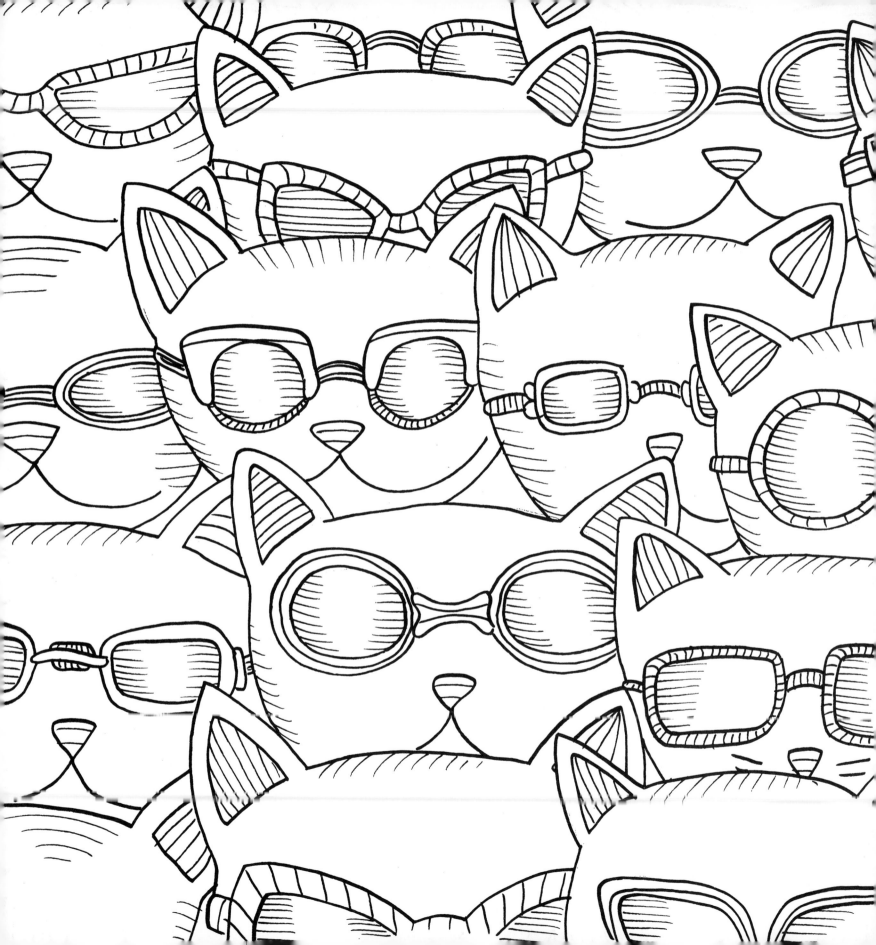

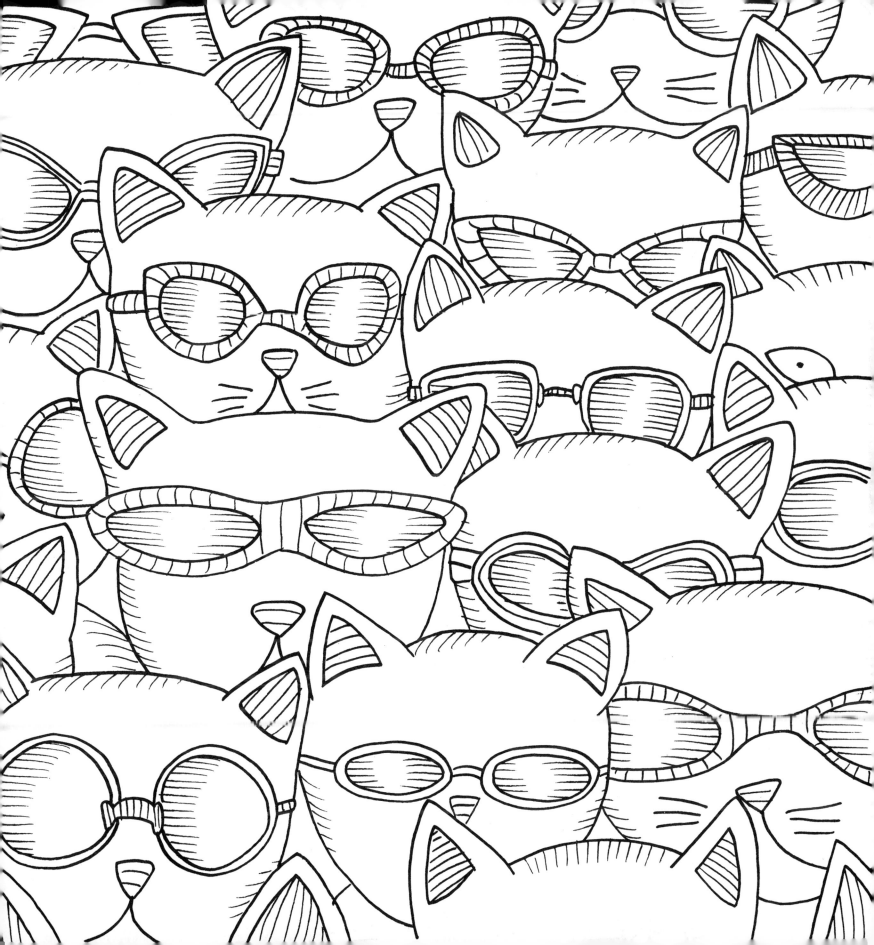

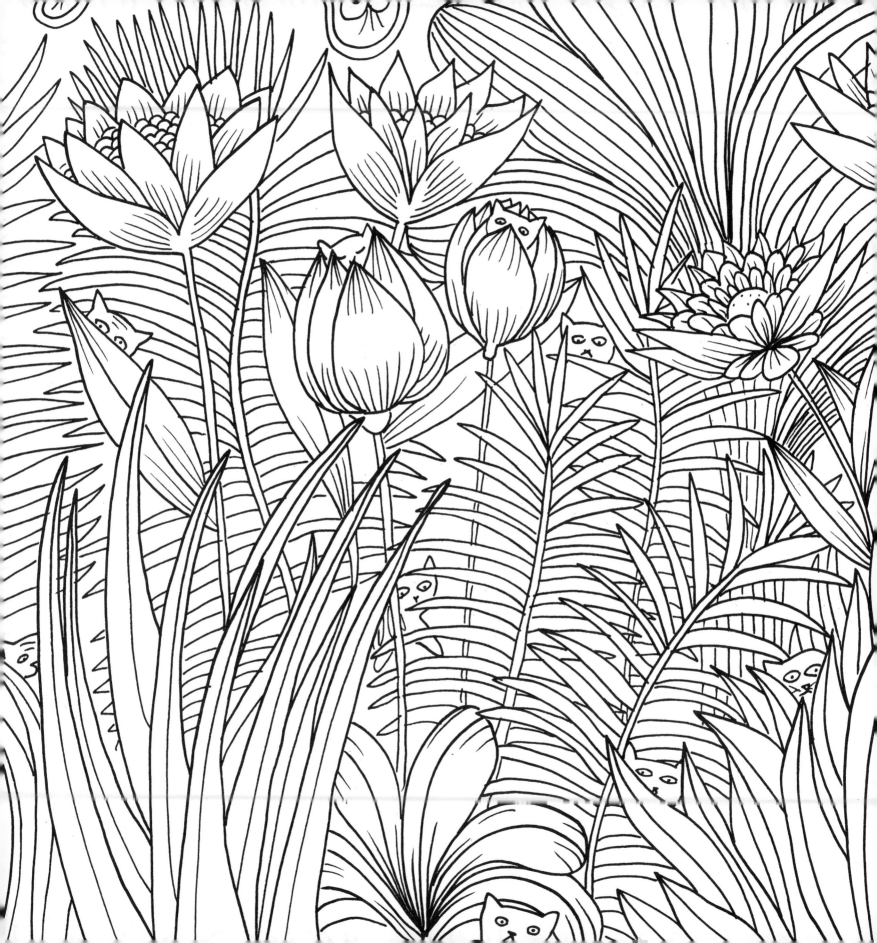

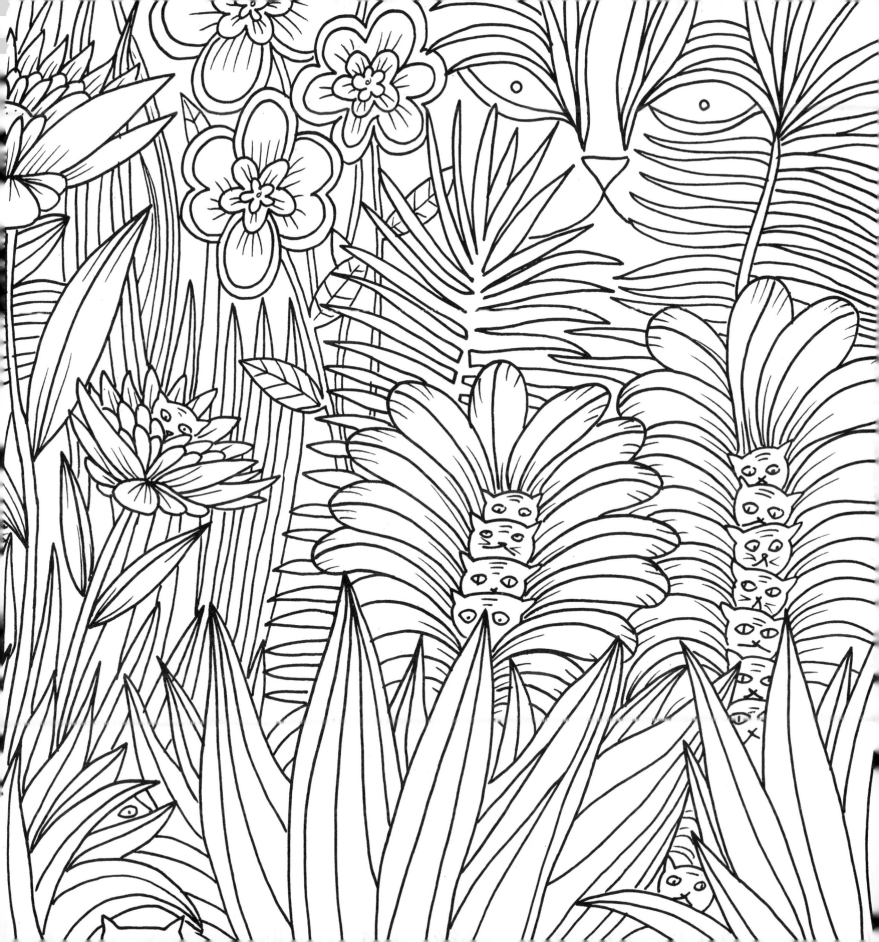

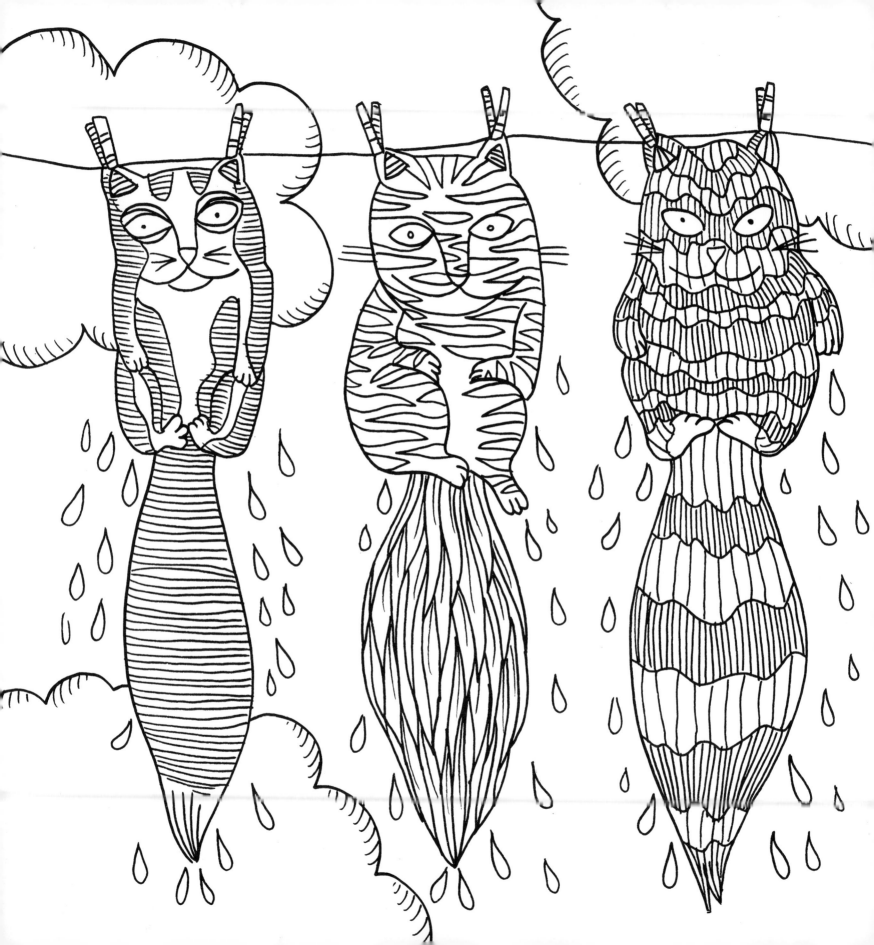

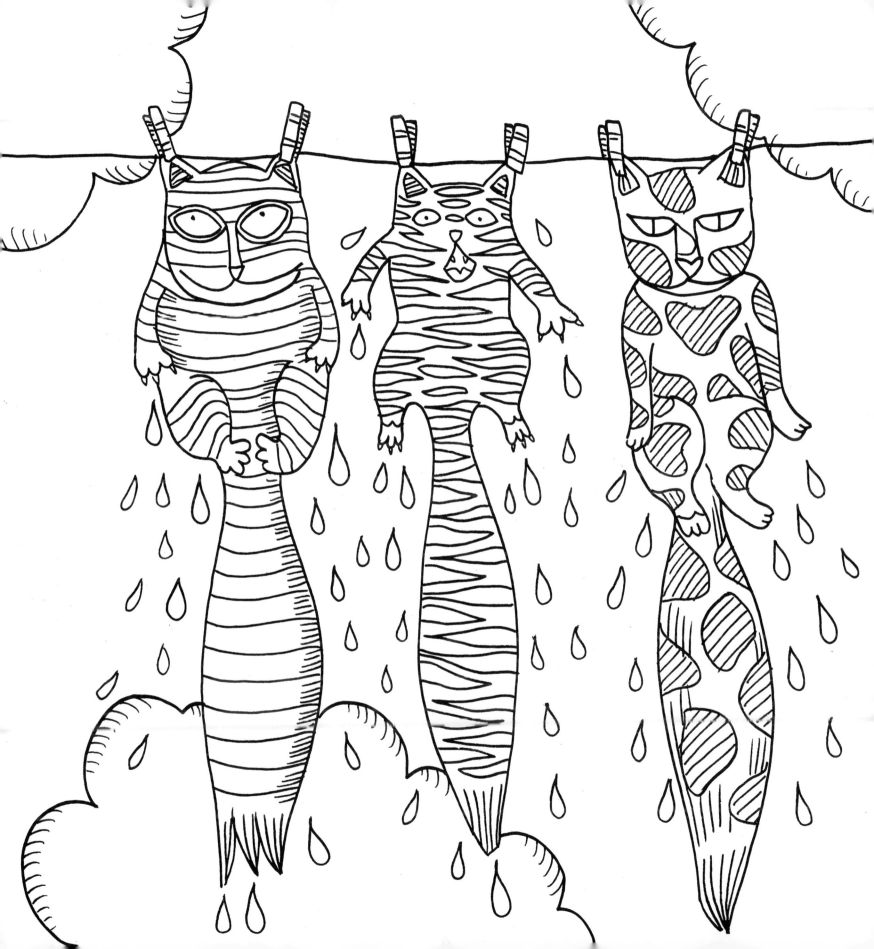

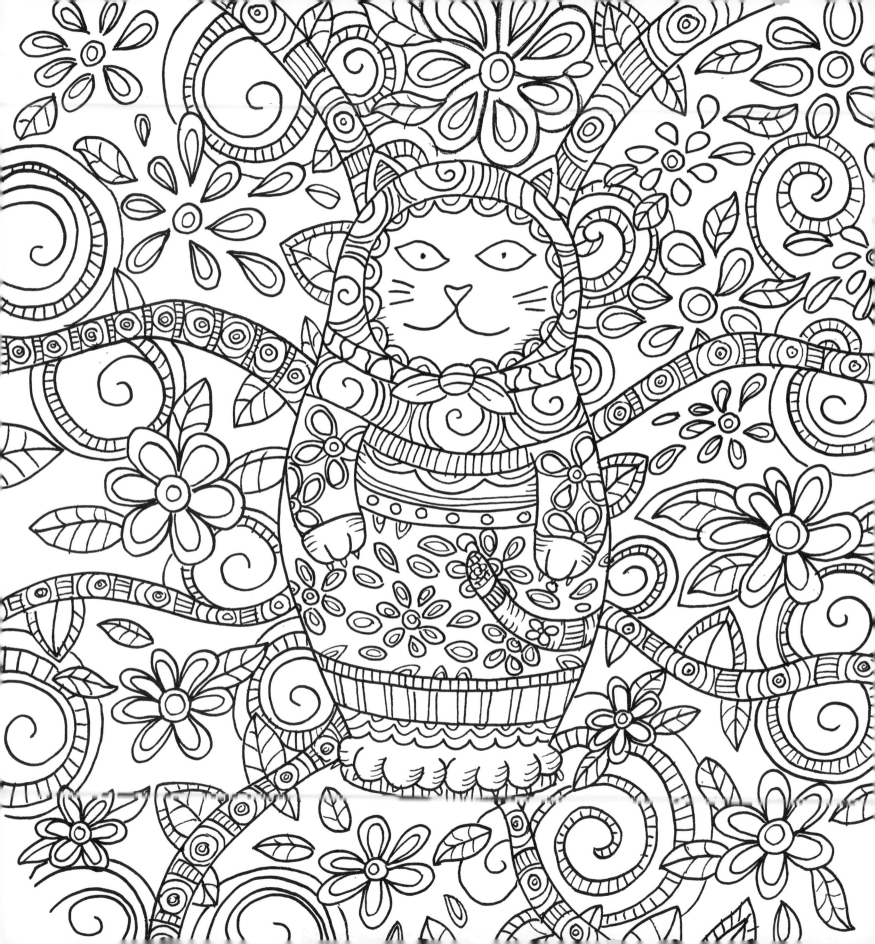

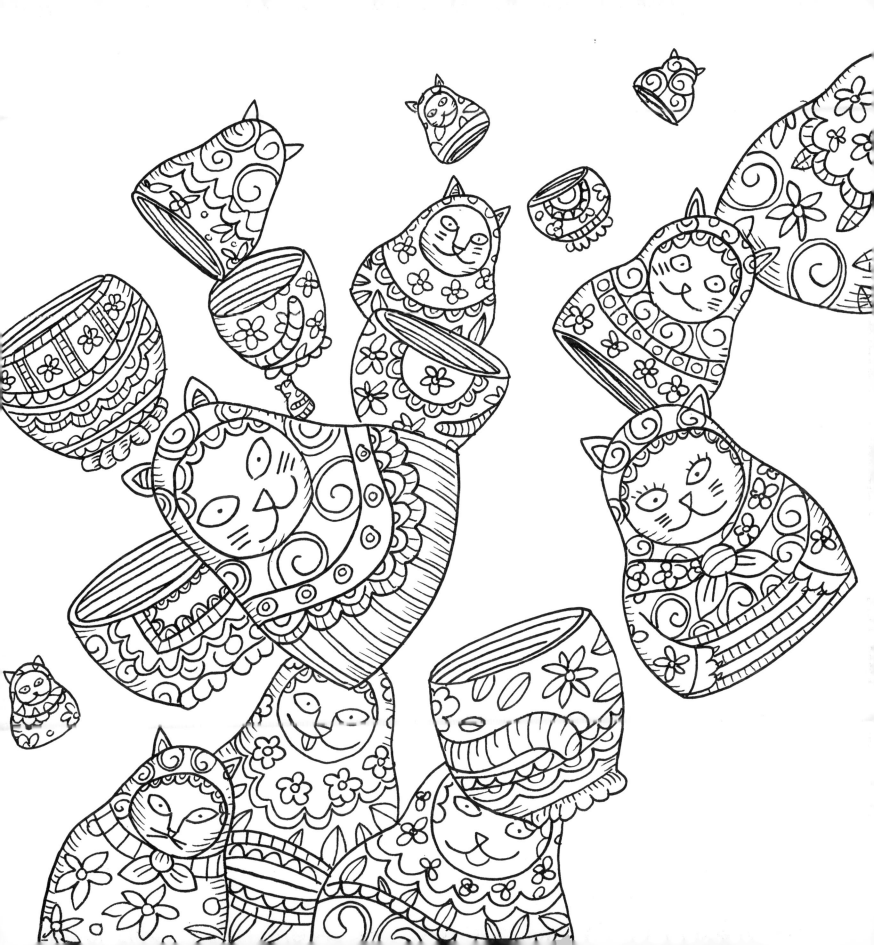

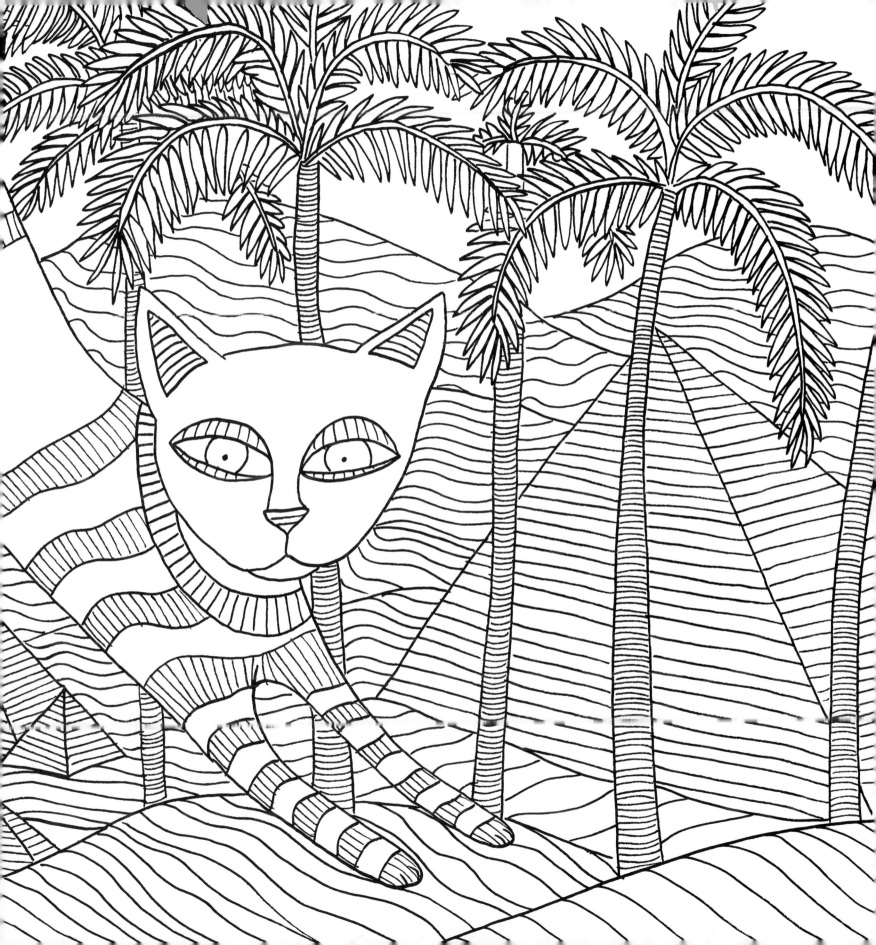

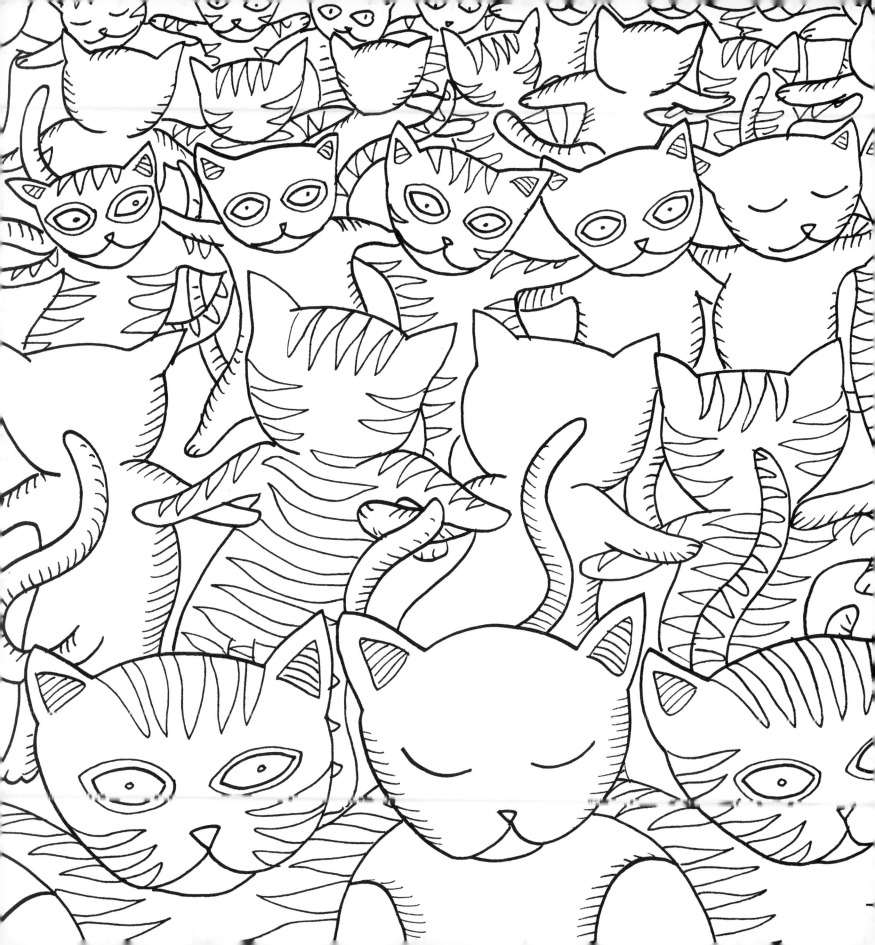

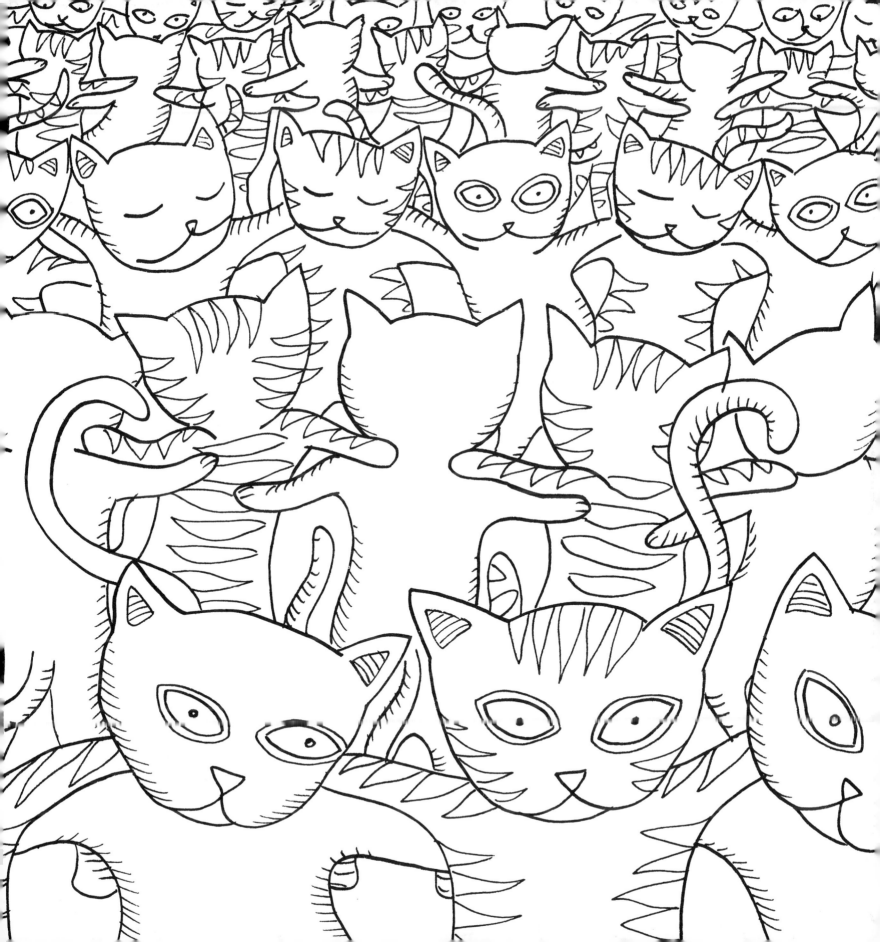

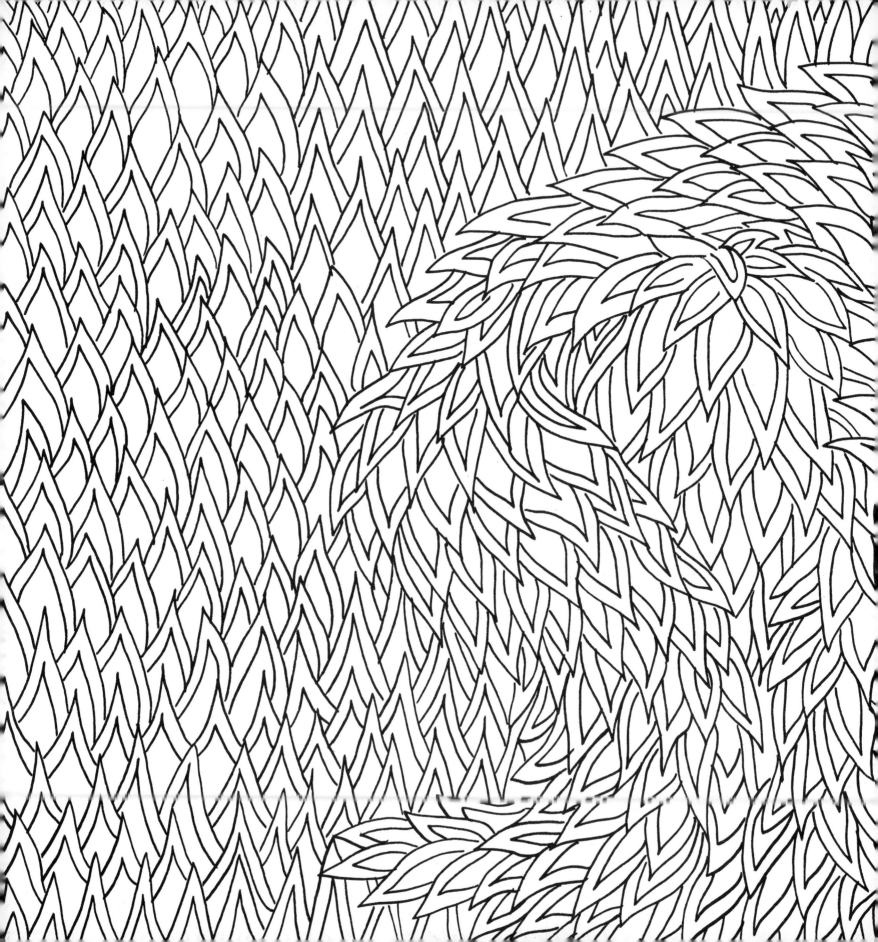

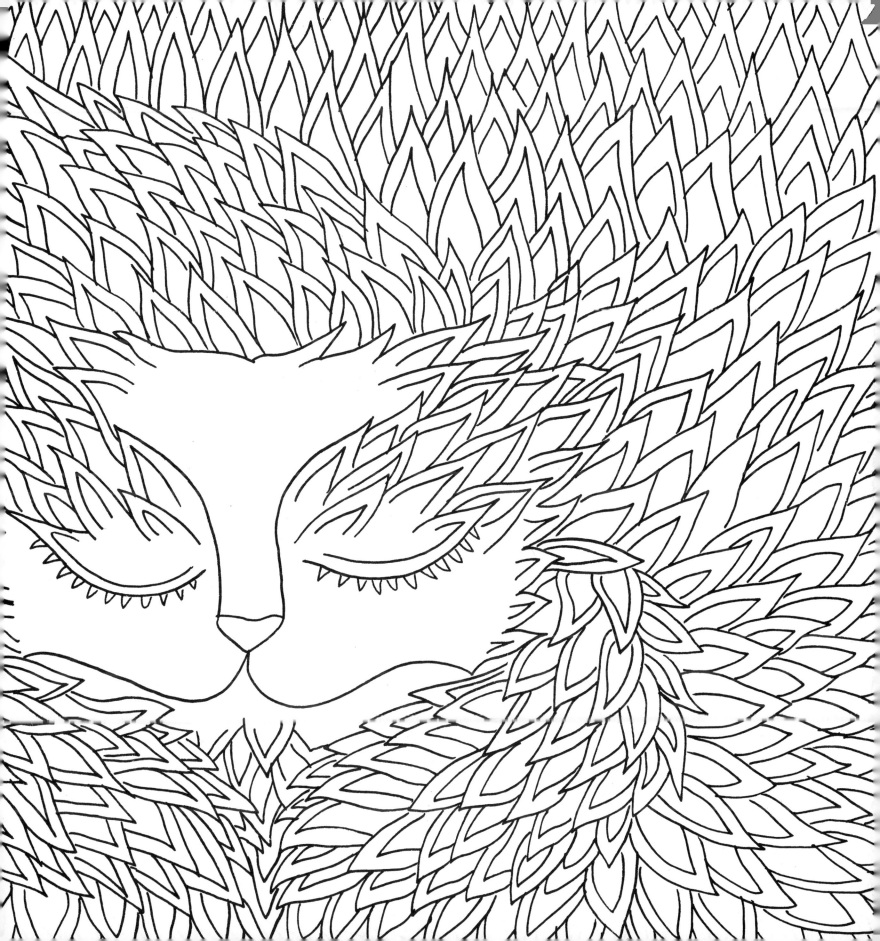

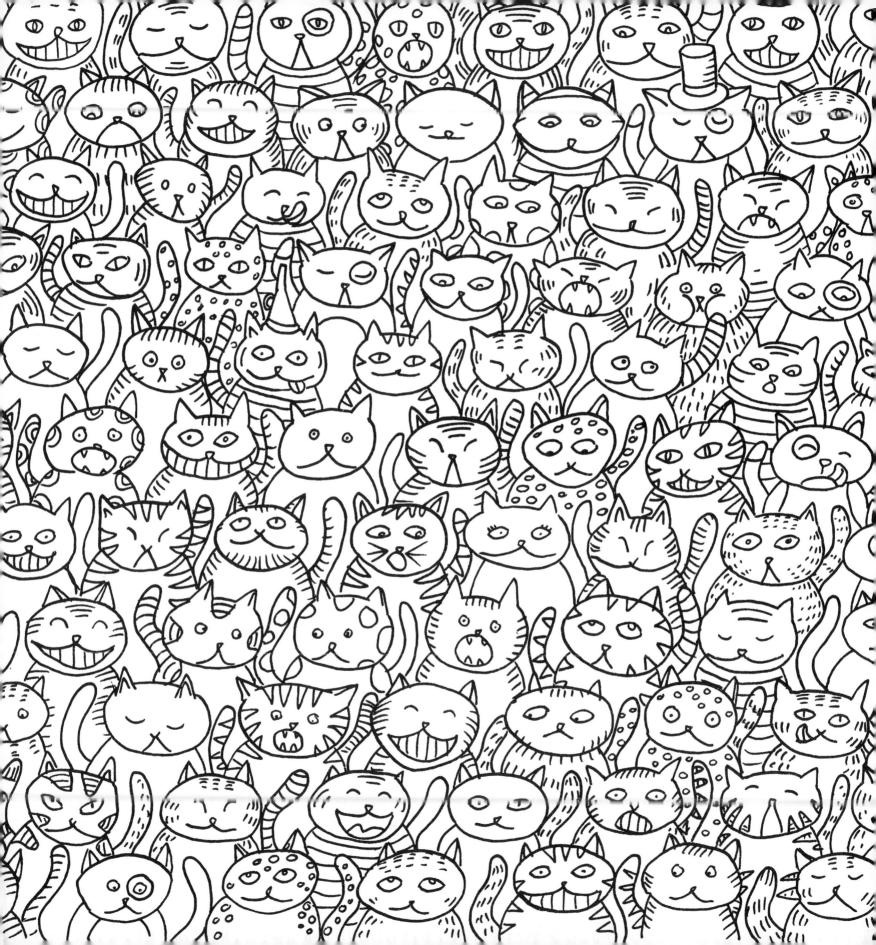

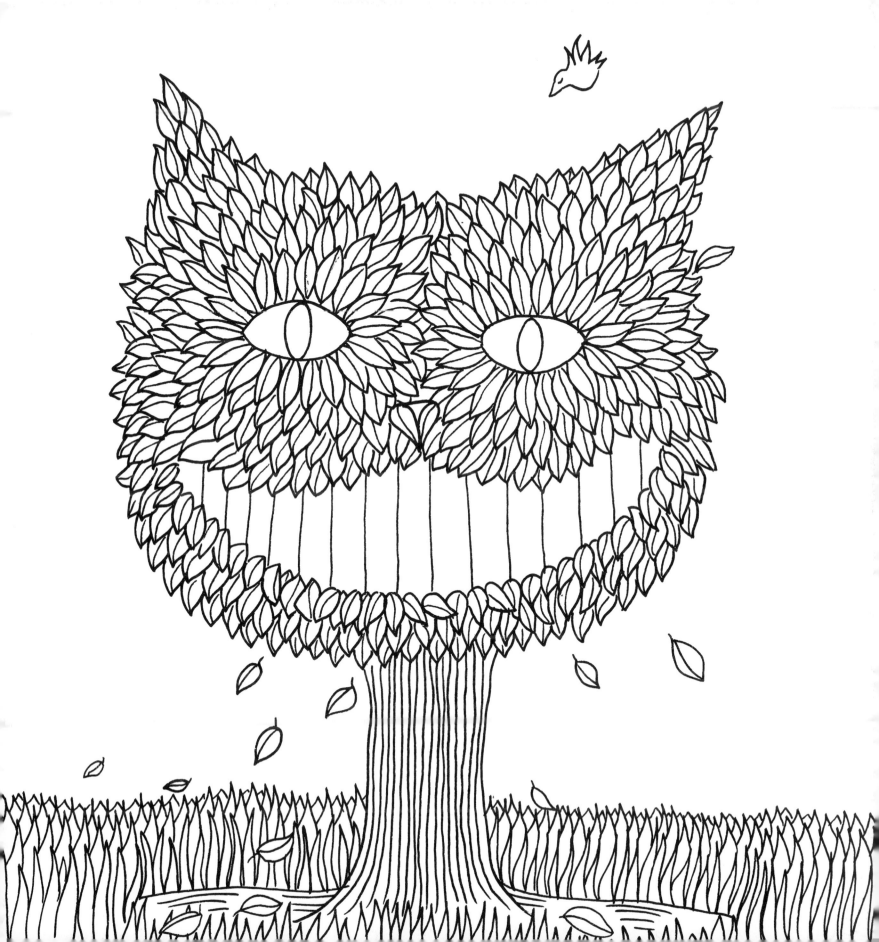

Narcissticat

The war of cats

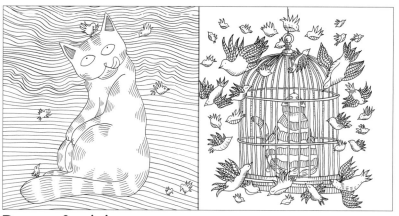

Dream & nightmare

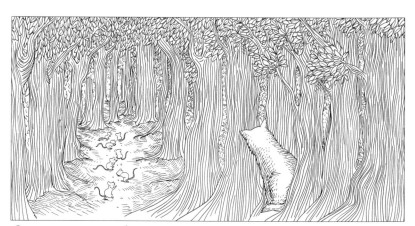

Once upon a time

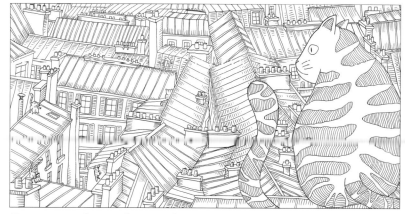

Cats on a hot tin roof

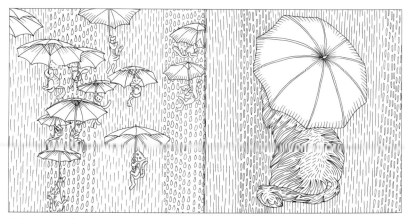

It's raining cats

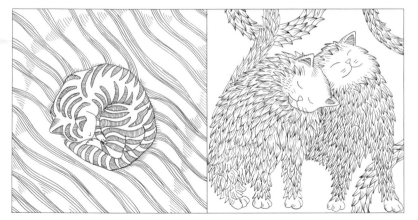

Purring pussies

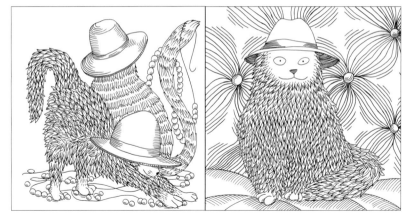

Cats in hats

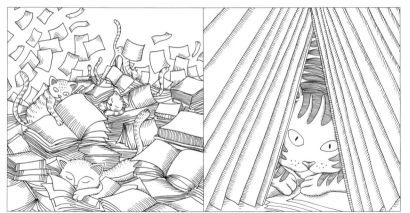

Bookish cats

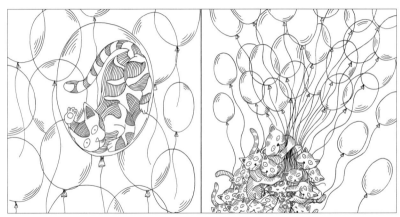

Up, up and away

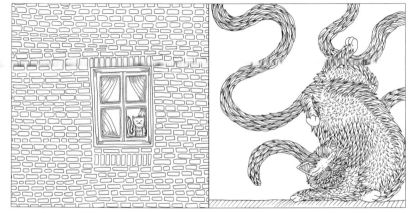

A window on the world

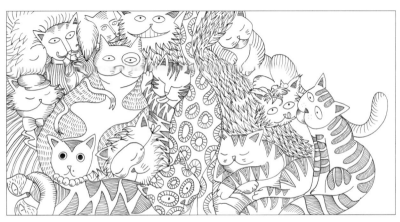

A cuddle of cats

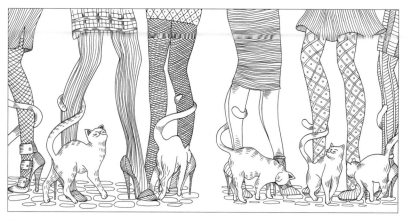

Each to his own

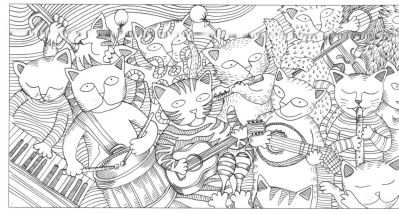

Cat cacophony

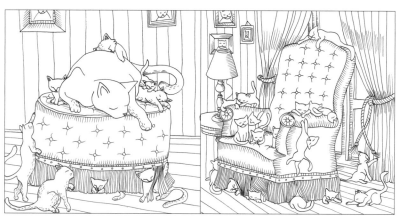

A favourite chair

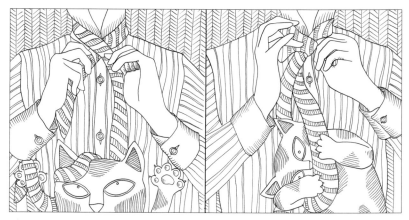

Windsor knot

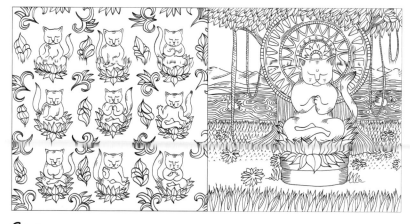

Guru

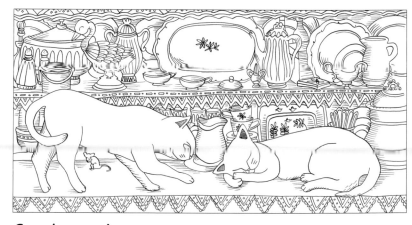

Cats in crockery

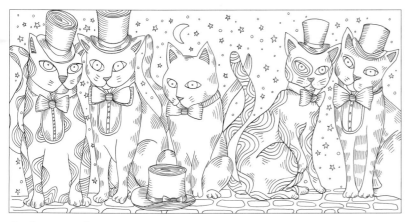

A day at the races

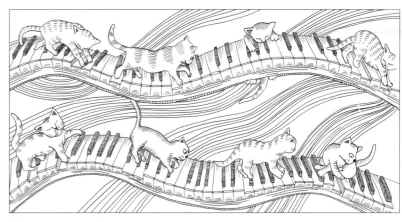

Paws on a piano

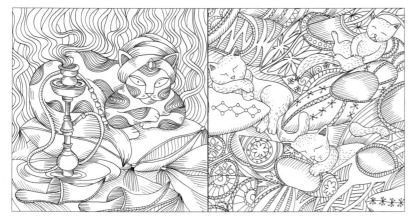

Persian cat

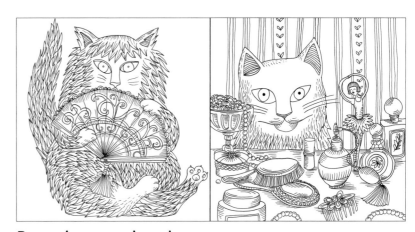

Boop-boop-a-doop!

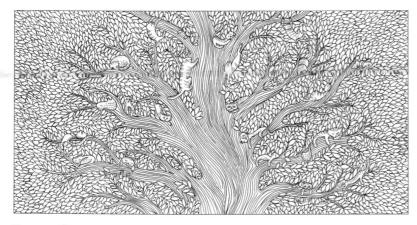

Tree of cats

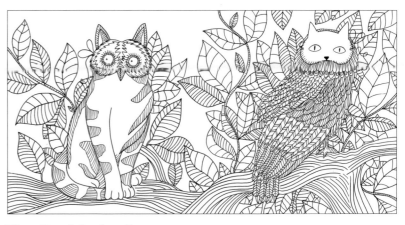

The Owl & the Pussycat

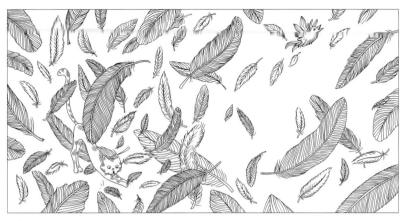

Chasing leaves

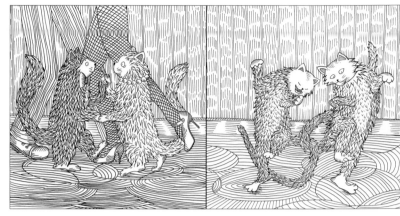

Cha-cha-cha!

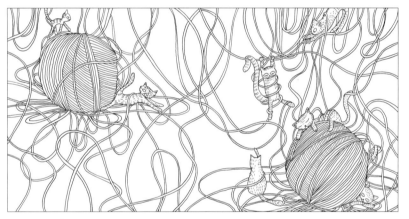

Balls of wool

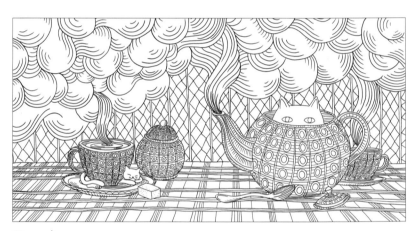

Tea time

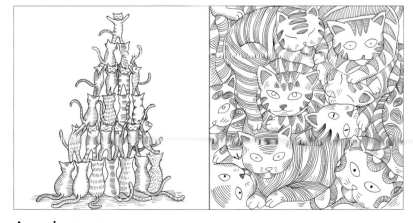

Acrobat cats

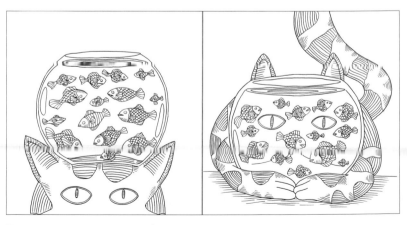

Tomcat's temptation

Thereby hangs a tail

Mix 'n' match

Kite cats

Cannes

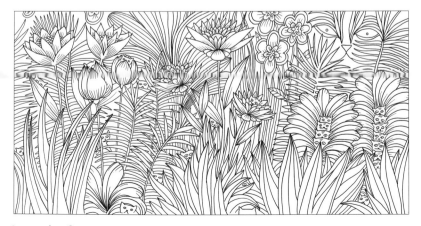

Jungle fever

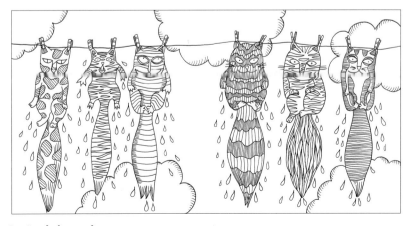

Washing day

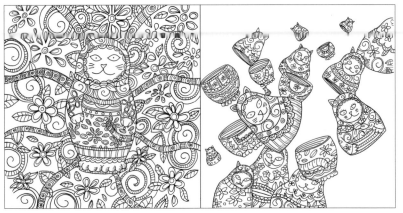

Babushkat

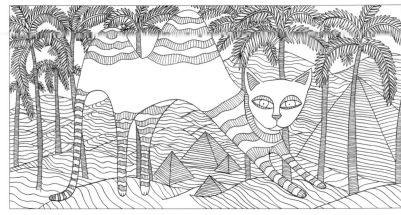

Camel cat

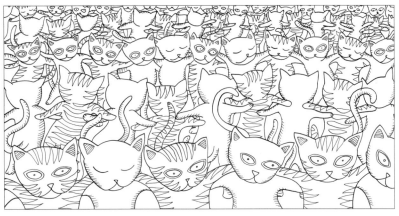

Zorba's Dance

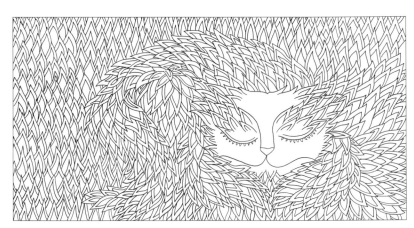

Now you see me...

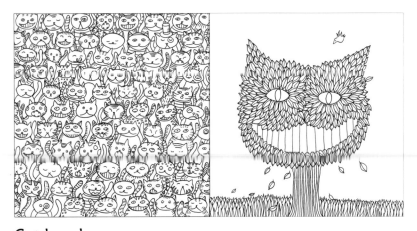

Cat heads

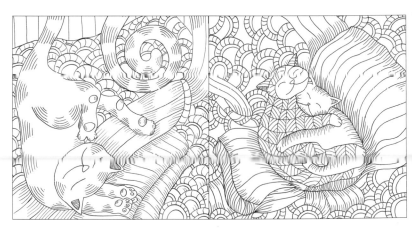

Siesta